# GHOSTS
## OF THE
## TREASURE COAST

**PATRICK S. MESMER AND
PATRICIA A. MESMER**

HAUNTED
America

Published by Haunted America
A Division of The History Press
Charleston, SC
www.historypress.net

First published 2017

Manufactured in the United States

ISBN 9781467136983

Library of Congress Control Number: 2017940921

*We dedicate this work to our family and all of the people who live along the Treasure Coast and helped us gather all of these fascinating stories. It is because of you that folklore is going to continue to be a wonderful part of our legacy.*

# CONTENTS

# CONTENTS

# PREFACE

In early 2016, I was approached by The History Press with a proposal to write about the ghost stories and legends of my beloved Martin County, Florida. I was definitely interested, mostly due to the fact that my first two books were loosely based on the same topics. I proposed to the publisher that we take the subject matter of this book one step further to include the entire area known as the Treasure Coast. It is one of the fastest-growing places in the country and was recently featured in the national news for significant discoveries of Spanish treasure along its shoreline. My wife, Tricia, and I have studied the folklore of this area for many years, and we were elated at the opportunity to share what we have learned. As you read further, you will be joining us as we explore the hauntings, apparitions and chilling stories that have emerged from the Treasure Coast's rich history. Thank you for accompanying us on our journey!

What is the definition of a haunted place? Do you believe that spirits can linger in an area or building long after life has left their mortal bodies? In today's hectic, material world, we tend to take many things for granted. With the constant bombardment of media images and split-second gratification, we tend to be skeptical of anything that we cannot see or touch. One thing that we often lose sight of is that we live in an old world—one that we are a very small part of. If we appreciate that there might be more going on than we realize, it may serve to open up a whole new appreciation of our lives and the impact we have on the world around us. We believe that hauntings are directly tied to the history of a place. In order to understand why there are

restless spirits in a particular area, one has to learn what tragic events took place there to cause them to linger. This is why the best ghost hunters are avid students of history.

When I was a youngster, the subject of history—as taught in school—was viewed by most students as incredibly boring and stilted. It seemed to be one event occurring after another on a multitude of dates that always came to an obvious, well-known conclusion. To put this in perspective, take the terror attacks on the World Trade Center in the year 2001. Just imagine students one hundred years from now seeing 9/11 as a footnote in a book and hearing the event recounted in a flat, analytical way by a boring professor. In reality, nothing could match the horror and confusion of that day. Also, the subject of history in general has almost always been slanted toward European influence, often leaving out the important contributions of countless ethnic groups and races. The truth is that history has always been fluid and unpredictable. Throughout the ages, almost all civilizations have produced mountains of brilliant folklore that have been handed down verbally through generations, usually told around a blazing fire. To us, this is the good stuff—the human element, so to speak.

What is the paranormal? Are there such things as ghosts? Do certain lost spirits linger after the physical body ceases to exist?

It seems that people have been fascinated by questions like these for centuries. In order to find answers, one needs to have an open mind. Almost every society throughout history has had a system of beliefs that revolve around faith in things that cannot be seen. Today, millions of people flock to churches to pay tribute to invisible deities in which they have unquestioning faith. All over the world, wars are fought over various beliefs in the afterlife.

Many theories abound concerning the study of paranormal activity. One popular idea is that there is another plane of existence among us that we cannot see, one that hums with the energy of life. All day long, we have millions of thoughts that are represented as bits of information. When we die, all of these tiny fragments of thought go into the higher plane, traveling at light speed. Every so often, we get small bits of this information that come to us randomly—or possibly intentionally—from some determined spirit that might be trying to communicate with us. Hence the popularity of the "spirit box" or EVP (electronic voice phenomenon) recorders that pick up these "messages."

The coauthors of this collection, Patrick and Tricia Mesmer, have been interested in the paranormal for a long time. Tricia's obsession with the controversial subject began when she was very young and encountered a

spirit of her own. Having lost her father, a U.S. Marine Corps drill instructor, at a very young age, she began to question the finality of death. In her room, she had a plastic record player that was a staple of a teenager's world at that time. After one particular night of listening to her favorite tunes, she decided to ask out loud if her father had "crossed over." She picked the stylus up off the record she had been listening to and set it down. She then walked across the room to sit on her bed. Breaking the silence, she asked the question out loud. To her utter amazement, the stylus raised itself into the air, as if lifted by an invisible hand, and gently set itself down on the record. As the song played, Tricia realized that she was scared but also very excited. To her, all of her beliefs had been confirmed in one instant. She unplugged the record player and sat back on her bed, staring at it. To her shock and amazement, the entire sequence repeated itself, this time without electricity. The song played for a few seconds and then stopped. Tricia concluded that her loving father had indeed contacted her through the songs that she loved. Ever since that experience, she has never looked back. This began a lifelong search for answers to age-old questions that continues to this day.

Patrick's interests lean more toward history. He is the author of several books on various aspects of Florida history and is a sought-after speaker in the area. He is also a weekend volunteer at Gilbert's Bar House of Refuge, one of the locations discussed in this book. He has a passion for history and believes in the power of a good story that is well told. He believes that it is very important to always keep an open mind. In today's world, it is wrongfully arrogant to completely discount something simply because you can't grasp it in your hand or see it with your own eyes. He looks at it this way: if you were to show someone from the Revolutionary or Civil War era a radio or a television set, how would he or she react? Chances are, after they awakened from passing out after the initial shock and fear, they would probably swear that it was a box possessed by some evil spirit. Knowledge changes every day at blinding speed, and we are constantly learning more about what the human mind is capable of. Let's face it: life is much more interesting that way, isn't it?

# Acknowledgements

Whenever a book like this is written, there are many people who are instrumental in aiding in its growth. We would like to thank the Martin County Historical Society and the Elliott Museum for allowing us to peruse their collections. They do a wonderful job of preserving the history of the area. The staff and leadership of Gilbert's Bar House of Refuge Museum was also a huge help. Linda Geary, curator of the museum, was especially helpful, as was her assistant, Michael Phillips. We would also like to thank all of the other volunteers who work so hard to preserve the wonderful history of the place. Their constant support has been a guiding light to us throughout this project. We would like to recognize the staff and friends of the McLarty Treasure Museum for their constant support, as well as the staff of the archives department of the Indian River County Library System. We also would like to thank the Martin County Library System and the State of Florida for their help accessing their archives and granting permission to use their wonderful collection of photos. We owe a deep amount of gratitude to our good friend Steve Carr for his donation of never-before-published photos of the Ashley gang. He also helped immensely with his laser-accurate editing and historical advice. He helped us to make this a very special publication. We would also like to acknowledge Beth Mazzouccolo and her daughters, Tera and Marissa, and Michael and Sandy Storm. We would like to thank the citizens of Port Salerno for supporting our local ghost tours and many others who helped us with this project.

Join us around the fire on the beach. Everyone loves a good ghost story!

# INTRODUCTION

Florida's Treasure Coast stretches across four seaside counties: Palm Beach, Martin, St. Lucie and Indian River. Many of the stories that you are about to read are commonly known to its longtime residents. As you share these tales with us, you will find that much of the folklore of the Treasure Coast is tied directly to the turbulent sea. Its beaches have close proximity to the north-flowing channel in the ocean known as the Gulf Stream. Discovered by Juan Ponce de León in the year 1513, this natural current has been utilized by great navigators, merchant mariners, fishermen and pirates for hundreds—maybe thousands—of years. The Treasure Coast is also known for having many miles of Atlantic coastline, much of it lined with treacherous reefs consisting of coral and a craggy substance called Anastasia rock. This limestone-based material makes up much of the bedrock of the barrier islands. The Treasure Coast lies in the area known as "Hurricane Alley," and many a storm has mercilessly thundered across the Atlantic from the African coast, wreaking violent havoc on our cities, communities and agriculture. For these reasons, the "Florida Channel" used by navigators traveling north from the Caribbean to Spain along the Treasure Coast was always considered to be the most threatening part of the journey for wind-borne vessels. Its entire length is littered with shipwrecks. This history has spawned many ghostly legends over the years.

# SEBASTIAN

# 1

# HOME OF THE ANCIENT ONES

One cannot talk about the ghosts of the Treasure Coast without discussing the people who lived there for thousands of years before European contact. Today, the land is covered by highways, housing developments, beachside condominiums and strip malls. Many do not realize that before Christopher Columbus "discovered" the New World in the year 1492, the land later called "La Florida" was already heavily populated with native people on both coasts. Comparatively little is known about these ancient residents. The best information we have has been gleaned from two main sources: sparsely written early Spanish accounts and what the native people left in their refuse and burial mounds. As far as the Treasure Coast is concerned, archaeologists know that there was a huge population of people living in the coastal area stretching from Jupiter Inlet to Cape Canaveral. These people were known as the Ais and the Jeaga and lived there as long ago as 800 BCE or possibly even earlier. Where they originated from is not certain, but what is known is that they thrived in the area for thousands of years.

In 1565, Spanish explorer Pedro Menendez made his famous landing at present-day St. Augustine, first meeting the northern tribe known as the Timucua. As his exploration moved south to the area now known as the Treasure Coast, he encountered the numerous and aggressive Ais. On old Spanish maps, the coastal areas of Brevard, Indian River, St. Lucie and Martin Counties are referred to as being part of the "Land of Ais." The main water artery that runs almost the entire length of the Treasure Coast

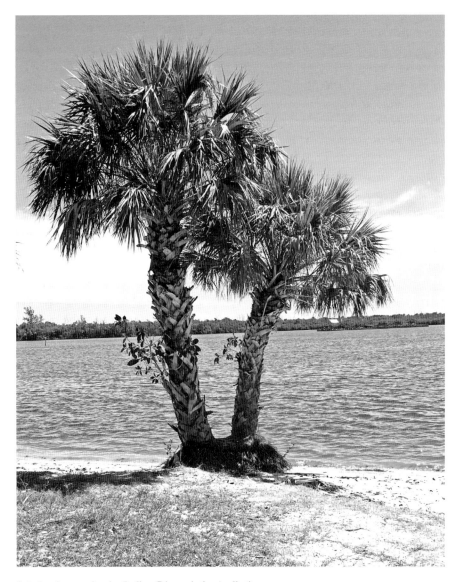

Sabal palm tree by the Indian River. *Authors' collection.*

was originally named Rio de Ais. Today, it is known as the Indian River. In the late 1500s, there were so many Ais people that the Spanish governor of La Florida commented that he had never seen so many Indians.

Who were these people? The Ais were what is known as foragers. They hunted, fished and gathered shellfish from the rivers for subsistence. They

18

did not have to grow food because it was an easy life. It only took about fifteen minutes a day to sustain themselves. They were migratory in the sense that they maintained villages and small settlements on the barrier islands in the wintertime and did the same in the mainland forests and swamps in the summer. They were very acclimated to South Florida's harsh climate and knew how to live with the extreme heat, voracious mosquitoes and vicious storms that frequently hit the coast. Today, many of their mounds, or "kitchen middens," are still visible. After consuming clams, oysters and small animals, they would discard the unused remains, eventually producing large piles of refuse. In time, they accumulated massive amounts of this material, so they would utilize it to create hills on which to worship and build their sacred buildings. These middens not only afforded them great views of the surrounding area, but they also provided high ground on which to be safe from floods caused by the summer squalls and hurricanes.

According to early Spanish and English accounts, the Indians performed terrifying rituals on these raised mounds as they tried to connect with the phantom spirits of their ancestors. Even though the majority of the midden material was removed early in the twentieth century for use in making roadbeds, there are still many left. There are also many burial mounds still around—if you know where to look.

The Ais had some rather bizarre rituals that were documented in early European encounters. The passing of tribal members was a great loss, and mourning was a huge part of their ceremonies. It was vital to show the utmost respect for the dead to ensure that they passed safely from one world to the next. It is believed that when one mound had a large number of bodies interred in it, a warrior would stand on top of it and shoot an arrow as high and far as he could. Wherever the arrow landed is where they would place the next burial mound. The people would then carry the dark sand from the river to the new mound site in baskets and carefully pile it over the body of one who had passed. For up to two months, several women would visit the site at the same time every day to cry and wail over the lost soul for many hours. The energy from rituals like this was so intense that the spirits of the Ais may still watch over the land around their middens and burial mounds. Many residual hauntings have been reported near these ancient structures. A residual haunting is an event that plays itself over and over again on the ground where the event originally occurred.

One of the best accounts we have of the occult belief systems of the ancient Florida Indians comes from the writings of Father Rogel, a Jesuit priest who traveled to Florida's west coast with Pedro Menendez in the

sixteenth century. According to his journal, the Indians believed that there were spirits and demons everywhere and the spirits of the dead were with them all the time. Each person possessed three souls, all of which migrated to animals after physical death. One was in the pupil of the eye, the second in the shadow cast on the ground and the third in the reflection on the water's surface. The soul that existed in the eye stayed with the body all the way to the grave and could be consulted after death. The remaining souls would be transferred into an animal, and if that animal was killed, it would transfer to an even smaller animal. This cycle would continue until there was nothing left of the soul. If someone got sick, it meant that one of the souls had escaped. The village shaman would then perform a series of rituals in an attempt to restore the lost soul to the afflicted man or woman.

## A DOOMED CULTURE

By the year 1750, the once great and numerous Ais people had completely vanished from the Treasure Coast.

What happened to them?

When Christopher Columbus landed at San Salvador, today's Dominican Republic, he and his men brought a deadly weapon with them that not even they knew about. The native people, as strong and threatening as they were, could not stand up to an unseen enemy. It is widely believed that this scourge was unwittingly unleashed by sailors who carried it from Europe. Smallpox, hepatitis, cholera and other communicable diseases took hold in the native population very quickly, tearing through people like paper burning. They had not developed any resistance to the plagues that had earlier decimated millions of people in Europe and therefore were magnets for the deadly viruses. A combination of Spanish brutality, alcoholism, slavery and communicable diseases took a deep and sorrowful toll. In as little as two hundred years, the native tribes had been almost completely decimated. It is hard to imagine the suffering and despair of these people as they watched their families succumb to the great plague. One can almost feel the sorrow that they experienced as they realized that, for some unknown reason, their gods had abandoned them.

What this means to current residents of the Treasure Coast is that nearly every time we take a step, we are walking on someone's grave. Our present culture has lived here, in South Florida, for a few hundred years. The Ais

A view from the beach in Sebastian, Florida. *Authors' collection.*

lived here for *thousands* of years. They lived, prayed, procreated, experienced infinite loss and died in droves in the very places where we now live. Does the dark energy of their powerful belief in the afterlife spawn strong forces that endure to this day, lurking in the very ground that we live on, waiting patiently for release? How many lost Ais, Jeaga and Calusa spirits still roam the remote areas along the Treasure Coast, guarding the places where their ancestors are still secretly interred?

## AN AIS INDIAN LEGEND

There is a legend that has been handed down for hundreds of years and actually was in print in the Vero Beach area in the early 1920s. No one is sure of its exact origin, but it has survived through the years. The version that follows is from the Vero Beach Historical Archives, provided by Rebecca Salinas. Before you read it, try to imagine what Vero Beach and Indian River County was like before the Spanish came.

*A very important Ais cacique* [chief] *had a beautiful young daughter. She was always very distraught, so much so that many could not see her beauty.*

*Part of her sadness was because her brother had already been killed in battle at a very young age. Because she was so forlorn, her father decided that he must do something to save her from her own grief. He had a gathering of all of the braves to test each one's strength and skill, because, well, what does a woman need, of course, but a man? Even though the best and the bravest of her people were presented to her, she sank deeper into her sorrow. One night, as murmurs grew into fearful excitement throughout the crowd, she looked up to see a large looming, ominous black mass that had come from the ocean. At first, she was filled with horror as she saw that it was approaching her. As it got closer, something changed inside of her. The people near her, especially her father, noticed a transformation come upon her face. They saw that she was radiating the utmost expression of happiness and peace. What did she see that others could not? Her brother? The black form then enveloped her, and she vanished. It then faded into the night. The legend goes on to say that this thing will visit the Ais every one hundred years to take away one person who is unhappiest and cannot live another second here on earth.*

# 2

# SPIRITS OF THE 1715 FLEET DISASTER

Florida's Treasure Coast is one of the most beautiful places in the world. Thousands of people flock to it every weekend to play and relax on the expansive, unspoiled beaches and enjoy the warm, tropical water, never-ending sunshine and briny breezes of what many believe is paradise. Surfers, parasailers and beach bums come from everywhere to gather along the seashore and spend time escaping from the rigors of daily life. It's hard to imagine that—at one time—it was seen as a forbidding and dangerous place. Many people believe that there are countless lost spirits that still roam the sandy beaches. Over the years, many tragic and apocryphal events have occurred on its shores, and many strange, unexplained occurrences have happened when moonlight bathes the sandy expanses. It's very easy to imagine that something very otherworldly exists there. Before you can appreciate the true level of paranormal activity on these shorelines, we have to discuss the history of the place. Only then can you get a sense of why it is called the Treasure Coast and why it is so haunted.

## THE TREASURE FLEETS

There were three main fleets, or flotillas, that regularly brought riches from the New World to Mother Spain. The Manila fleet brought fine china, spices, silk and many other treasures from the Orient across the great Pacific

to Acapulco, where they would then be transported over the mountains by mule to Vera Cruz. The goods would then be loaded onto the great ships of the New Spain fleet and taken to Havana, Cuba. The Tierra Firme fleet brought gold and silver from Portobello, on South America's northern coast, to Havana as well. The city was the center of the Spanish universe in the Caribbean at that time. It was the hub of all of the treasure fleets and the most strongly defended port in the region.

In the year 1715, a long war in Europe had just ended, so the Spanish government was in financial trouble. The young wife of King Philip the Fifth had just died of consumption, so the Spanish chancellery had arranged a marriage for him. The weak king found himself wed to Elisabeth Farnese, the Duchy of Parma, Italy, a fiery, dominant woman who already had three children. She told Philip, who was addicted to sex, that she would not consummate the new partnership until her family received an enormous dowry. This treasure was still in the New World, its delivery delayed due to the long war. In Cuba, the admirals of the two main fleets that were commissioned to transport it to Spain were under a great amount of pressure to leave as soon as possible. Admiral Ubilla of the New Spain fleet had developed ulcers from worry about his mission and was anxious to finally get underway. There had been many aggravating delays to the fleet's departure, one of which being that it had to wait for the last remaining treasures of the vast dowry to be brought in. This included gold, silver, emeralds, pearls and fine china packed in mud from the Orient.

Finally, in late July, eleven of the finest vessels of the Spanish Main sailed out of Havana Harbor, along with a small French ship—*El Grifon*—that was tagging along for protection against piracy, which was rampant at that time. They had excellent weather for the first few days, and a quick and safe trip across the sea to Seville seemed likely. The mighty galleons made good time as they wound their way up through the Bahama Channel and then north along the eastern coast of Florida. They utilized the natural currents of the Gulf Stream to propel them along. On Monday, July 29, 1715, the air became humid, and the wind died down and seemed to stagnate. There were great rolling swells that rocked the galleons slowly. The old sailors began to complain that their joints and bones ached, making the younger men nervous with their talk of a blow that was surely coming soon. By Tuesday, the sky darkened and the wind began to howl, rocking the ships back and forth as the men on board struggled to remain calm and maintain their northern course. At around eleven o'clock that night, the wind reached storm level and was screaming through the rigging.

The rain was heavy as well, pelting the sailors like bullets as they held on tight. Midnight passed, and the full hurricane-force winds were now unleashed. Huge waves pounded the decks of the ships, nearly swallowing them completely as they bounced crazily and were driven even closer to shore. Slowly, the galleons were forced in toward the shoreline, even as the admirals fought with all of their might to turn them into the wind. Soon, they were forced to give up, surrendering to their inevitable fate. At approximately 4:00 a.m. on July 31, the devastating end finally came. One by one, the great vessels hit the reefs near the shoreline, most of their wooden hulls disintegrating instantly with the impact. Hundreds of men, women and children were thrown overboard, either drowning immediately or being crushed by falling splintered masts and rigging. The ones who survived were left to swim desperately toward shore.

The morning sun rose to illuminate a ghastly scene. Every one of the mighty, majestic galleons had been transformed into smashed hulks, half submerged in the water, their remaining masts lurching out in all directions, their tattered sails billowing gently in the warm winds of the post-storm ocean. It looked as if a giant child had destroyed all of his toys in a fit of rage. All of the vast treasure that they had been transporting was scattered over the shallow ocean floor or lay deep within the bowls of the wrecks. Thirty miles of beach were lined with close to 1,500 bedraggled survivors who sat in fear and confusion about what had happened to them. Many of the ones who didn't survive—more than 1,000 souls—floated peacefully in the gentle waves alongside the wrecks, at least until the swish and splash of a dorsal fin signaled that the sharks had found yet another feast. As the day progressed, the blazing July sun beat down on the hapless throng, increasing their misery tenfold. There was no fresh water, no cover from the sun save for the low scrub beyond the dune line and no food or clothing. When early evening came, offering some respite from the heat, they were attacked by voracious hordes of insects that ravaged every square inch of their bodies. Some were so desperate to escape this that they buried one another up to their necks in sand to hide their exposed flesh. Many died in the ensuing days from the stress of the dire situation they were in. The misery continued for weeks until the relief boats arrived from Havana and St. Augustine. By then, the few survivors were in a miserable state, indeed.

It is said that, on learning the news of the disaster, King Philip fell off his throne in a dead faint. Spain had suffered a loss so great that it would take a miracle to recover. The Spanish government scrambled for a solution, and a decision was hastily made. The Spanish would try to get as much

of the treasure back as they could. Word of the king's wishes traveled fast, so soldiers were quickly sent to "Palmar De Ays," as they called the area near present-day Sebastian Inlet, to do what they could. A salvage camp was established, and the process of recovery soon began in earnest. The salvagers pressed local Indians into service and rowed large groups of them out over the known wreck sites. They were then used as divers and sent down to the depths, holding large rocks to help them sink quickly to the bottom to forage around for whatever treasure they could locate. When they got back to the surface, they were searched for any stashed treasure that they may have found. The Spanish also used diving bells to enable the divers to snatch breaths at greater depths. If one of the Indians drowned or got the bends, he would be quickly replaced with another. The salvagers were relentless in their quest for lost treasure. It is estimated that, through their exhaustive efforts, they recovered up to five million pieces of eight from the wrecks that were strewn out along nearly forty miles of La Florida's barren coast.

News of the tragedy spread through the Caribbean like wildfire. It was as if a great dinner bell had sounded, and thousands of men flocked toward La Florida with one thing on their minds: treasure. This included privateers, pirates and looters. The royal governor of Jamaica, Lord Archibald Hamilton, wanted to take advantage of Spain's misfortune. He commissioned two privateer ships—the *Barsheba*, commanded by Henry Jennings, and the *Eagle*, led by John Wills—to secure the site for salvage and fight off any pirates they encountered. Jennings was more pirate than privateer himself and had plans to take the treasure by force if he had to. His crew was made up of several men of "questionable" reputation, such as the infamous pirate Charles Vane.

As they sailed up the coast of South Florida, they began to see evidence of the tragedy. Many abandoned campfires and crudely constructed shelters indicated the earlier presence of survivors, and hundreds of makeshift crosses constructed of splintered wood marked the resting places of shipwreck victims. They soon spotted the hastily constructed and poorly defended Spanish blockhouse fort in the distance. Using his spyglass, Jennings could see the salvage effort in progress. He anchored his ships a short distance south of the camp and, in the darkness of night, went ashore with up to three hundred armed pirates. At the break of dawn, they arrived at the fort and, in a quick, violent skirmish, quickly overtook the outnumbered Spanish soldiers. Jennings and Vane took over 350,000 pieces of eight back with them. Their success marked what is today known as the high point of the "golden age of piracy" in the Caribbean.

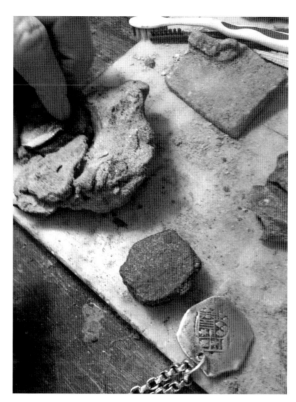

*Right*: Spanish coins found near an Ais Indian mound. *Steve Carr collection.*

*Below*: Mel Fisher (*left*), treasure diver. *Archive Center, Indian River County Main Library–Indian River County Historical Society Collection.*

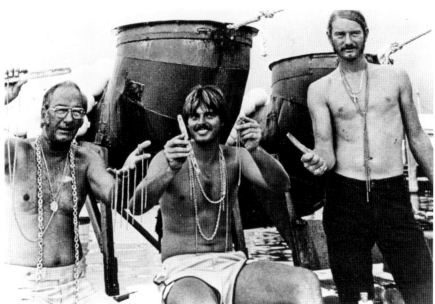

These monumental events solidified the reputation of the Treasure Coast. It is estimated that millions of dollars in gold, silver and emeralds still lie on the ocean floor in shallow water, buried by varying amounts of sand and debris. Much has been found over the years by expert treasure hunters like Kip Wagner, Mel Fisher and, most recently, the *Capitana* crew, who found over 350 gold coins in fifteen feet of water. Their wonderful discoveries have helped us put together the real story of what happened on that fateful night over three hundred years ago.

The rest of the lost treasure lies among the bones of the people who continue to guard it. The entire area is, in fact, a cemetery for the thousands of shipwreck victims who lost their lives in a sudden, tragic way. From Indian slave divers to Spanish soldiers, pirates and privateers, the place is alive with the ghosts of those who lost their lives on the Treasure Coast. Many treasure hunters who still search for their own bit of the loot report that, as they wander the beach, they get the sensation of hidden eyes upon them, as if someone is watching from some veiled place. Beachcombers have heard what sounds like crying or wailing from among the dunes. When they search for the source of the sounds, no one is there. A few have told of strange lights coming from the water, even though there are no boats or vessels in the area. Over the years, there have been random reports of ghostly shapes floating above the beach along the dune line. Sometimes, when the surf is high and the wind howls through the sea grapes, one can almost hear the thin, high screams of lonely, lost souls. Are they the remnants of the lost victims of the 1715 fleet? Or are they spirits of one of the many hundreds of other shipwrecks that lie along the treacherous reefs of the Treasure Coast?

## HAUNTED BEACH

Over the years, strange things have been reported on the beaches near where the wrecks occurred so many years earlier. Longtime Treasure Coast resident Jim Wilson shared an experience with us that happened to him many years ago. In qualifying his story, Jim explained that, ever since he was a child, he has possessed a certain "talent." His grandmother and his aunt used to say that young Jim had "it." What they meant was that he had the ability to see things that many other children did not. According to Jim, after she passed away, his grandmother's spirit would come to visit him. Late at night, when he was supposed to be sleeping, she would come. She would calmly sit on

the edge of his bed, and they would talk with each other. Alarmed at hearing voices in the room, Jim's mom would open the door, only to see Jim sitting upright in his bed, all alone. When she inquired as to who he was talking to, he gave a short, confident reply: "Grandma." This event recurred a few more times and then ceased. Today, Jim's ability would be called intuitive or possibly even psychic.

When Jim was twelve years old, he went on a school field trip to Mel Fisher's headquarters. He was fascinated and learned about the wrecks and lost riches from the famous treasure hunter. He also learned about metal detecting, a skill that he continues to practice to this day. Over the years, he has spent many nights on the Treasure Coast beaches with his beloved photography equipment and has seen and heard many things that he would classify as paranormal.

It was 1974, and many young people loved to hang out and party on the still undeveloped beaches and parks of North Hutchinson Island. One of their most popular gathering spots was Round Island Riverside Park, a wildlife refuge that lies about halfway between Fort Pierce and Vero Beach. It is a beautiful place located right in the heart of the Treasure Coast. This particular summer evening was dark, muggy and completely moonless. Jim had come out to spend time with his friends, most of whom had already been imbibing quite heavily. He was not a drinker and soon realized that he was the only sober person there. One by one, all of them either went to bed, passed out or found young girls to slink off and make out with. He found himself alone. It was very dark, and for some reason, he became restless and uneasy. Many of the guys had either driven there in their own cars or rode motorcycles, but Jim had no keys. Frustrated, he tried to wake one of his buddies from his drunken stupor. Unable to do this, he gave up and decided to go for a hike on the nearby beach.

It was so late that the transition to early morning was near, and he could feel the sand gnats starting to feast on the bare skin of his arms and legs. As he smacked the insects with his open palms, he tried not to become depressed about his situation. Inexplicably, the "no-see-ums," as they are called by native Floridians, abruptly stopped attacking him. For some unknown reason, they seemed to grant him a brief respite from their torturous gnawing. As he walked along, he felt himself relax as the gentle sea breeze and the calming sound of the endless waves on the beach did their trick on his psyche. Just as his mind started to wander, he heard a strange noise. It was a low keening—almost like a whine. The sound sent a cold chill through him, and his heart immediately leapt with fear. At first he thought

it was an injured animal—possibly a cat. Then, as he moved closer to its source, it became something else. It was a woman's voice, and he recognized the language as Spanish. She was moaning words as if in great pain and misery. Most of them were unintelligible, but he could make out certain phrases: "*Por favor me ayude Dios.*"

Jim understood a little of the Spanish language and knew that the words were of a deeply religious nature. He ran to the area at the top of the dune line from which the voice seemed to emanate. He was certain that he would find the badly wounded lady lying in the grass somewhere, and he had to find her. He saw nothing, so he looked even harder, pulling the high sea oats aside for many yards inland. Almost as abruptly as it started, the moaning ceased. He frantically searched for a few more minutes, anxiously calling out to her. A long time passed, and he was forced to give up.

Bewildered, he walked back to the campsite, where he found the most comfortable place he could and tried to sleep. All night, he could not stop worrying about the woman in the dunes. The next morning, all of the group was awake, groaning with the pain of hangovers. Jim, still frantic, implored his friends to come with him to help find the wounded woman. Begrudgingly, two of them followed him up the beach, shielding their red eyes from the already pounding rays of the morning sun. When they got to the spot, there

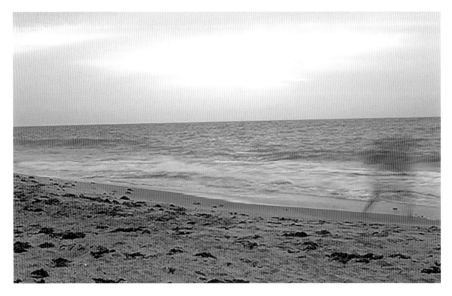

The photographer was alone on the beach near Vero when this picture was taken. Or was he? *Photo by Jim Wilson.*

was no woman, and they saw only one set of footprints in the sand. They searched the entire area, finding nothing. After enduring a lot of ribbing, a dejected Jim followed the skeptical boys back to camp.

A few years later, Jim learned more about the tragic shipwrecks that had occurred on that very beach in 1715. He was stunned as he read of the heart-wrenching misery that the survivors were forced to endure as a result of the disaster. He felt great sadness and pity as he learned that many of the survivors died right there on the beach, succumbing to the shock of the disaster, lack of water and supplies and harsh conditions. Still, he had never fully understood or comprehended the true, terrible loss of life and misery connected to the tragedy. The paranormal encounter that he experienced on that dark, wind-swept beach really brought it home for him. As far as Jim Wilson is concerned, he had heard firsthand just how miserable the plight of the survivors was during those blistering August days. The woman's ghost had told him the truth of the lost ghosts of the Treasure Coast.

# VERO BEACH

# 3

# WALDO SEXTON AND THE DRIFTWOOD RESORT

As you cruise down the highway that runs along Florida's Treasure Coast, you will see the seemingly endless parade of condominiums and strip malls that have become so endemic to the South Florida coastal landscape. Just when you think all of the original natural beauty of Florida is lost, you will come to Ocean Drive in Vero Beach. As you cruise down the seemingly typical beach-side avenue with the usual array of high-end souvenir shops, something different will catch your eye. On the east side of the road, you notice some tall, obviously handmade, slightly tilting pillars. When you take a closer look, you see that they are made of shell rock, stones and mortar, and each one is adorned with an intricately detailed wrought-iron lantern. The pillars mark a driveway with two entrances: one in and one out. Between the entrances are several ornately detailed frescoes, each one depicting a different scene of Spanish conquistadors and their initial meetings with Florida's indigenous people. To the south of these frescoes is another display featuring a large ship's anchor connected to a massive iron chain. In the center of all of this is a contemporary sign welcoming you to the famous Driftwood Resort.

The Driftwood is the brainchild and lifetime project of an energetic and eccentric man named Waldo Sexton. He has indelibly left his mark on the place, as well as on South Florida's turbulent history. Waldo is a very difficult man to describe and categorize. He has been called everything from an enterprising and cunning developer to a charlatan and an eccentric old fool. The truth is that Waldo Sexton is one of the most colorful personalities

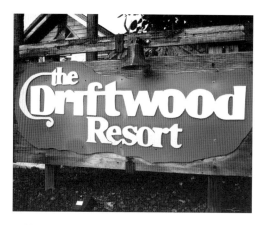

Driftwood Resort sign. *Authors' collection.*

the Treasure Coast has ever produced. To this day, many people claim to have met him during their visits, and it seems that he is always glad to see them. There is only one problem: Waldo has been dead for almost fifty years. He passed away in the year 1967. It is widely believed that his spirit survives and walks the boardwalks and breezeways of his odd resort.

In 1914, Waldo Sexton arrived in Vero Beach, Florida. It was a new world for him, having been born and raised in Shelbyville, Indiana. An energetic young man who had recently graduated from Purdue University's School of Agriculture, Waldo was interested in selling tilling machines to local farmers. He liked the area so much that he decided to stay, getting a job with the new Indian River Farms Company. Through diligence and hard work, he eventually purchased land in the area, on which he began to grow his own citrus trees. By 1917, he had become a prosperous independent grower. As the years passed, he became wealthy and was very much involved with the local citrus economy, owning and running the Indian River Products Company and helping to set up the Indian River Citrus League. Waldo became so proficient at growing superior vegetables and fruits that the U.S. Department of Agriculture named a variety of avocado after him. He then formed the very first dairy in Indian River County, the Vero Beach Dairy, and became a pioneer in the development of a tougher breed of cow that could blossom and flourish in the harsh conditions of the Florida summers. As the Great Depression took its toll on the local growers, Waldo joined the Florida Production Credit Association, a group that provided loans to farmers in tough times. He got involved in local real estate and grew even more prosperous, serving as president of the Vero Beach Realty Company for many years. Waldo Sexton was not your average man.

As he grew more successful, Waldo became a tireless promoter of local tourism, touting the beauty and potential of his beloved Vero Beach whenever and however he could. In the 1930s, he partnered with a man named Arthur McKee to form the popular attraction McKee Jungle Gardens. The place

Driftwood Resort tree root cave. *Authors' collection.*

originally covered eighty acres of tropical hammock along today's U.S Highway 1 in Vero Beach. The two men hired a well-known architect, William Lymon Phillips, to design the lush landscape of the place, focusing on beautiful overgrown trails, picturesque ponds and flowing streams. They then amassed the most impressive collection of water lilies and orchids in the

world, as well as countless species of both exotic and native plants, trees and shrubs. The beautiful gardens also had an aviary, a population of monkeys and a large alligator named Ole Mac. Waldo deemed himself the "idea man" of the place and personally entertained guests, often appearing with a monkey on his shoulders. McKee Jungle Gardens quickly became one of the most popular attractions in Florida at that time, drawing well over 100,000 guests a year.

In the early 1970s, the completion of Interstate 95 and the birth of the mega theme park to the west, Disney World, touted a new era in Florida history. After decades of success, interest began to fade in Waldo's attraction. It was forced to close its doors in 1976, unable to compete. Most of the land was sold and covered by a golf course and condominiums, with eighteen acres of it lying dormant for over twenty years. Recently, with interest in botany experiencing a resurgence, the gardens were reopened. In 2001, McKee Botanical Gardens opened its gates. It remains very popular to this day.

During the 1930s, Waldo built the original structure of what would later become the Driftwood Inn. It had two adjacent buildings separated by a

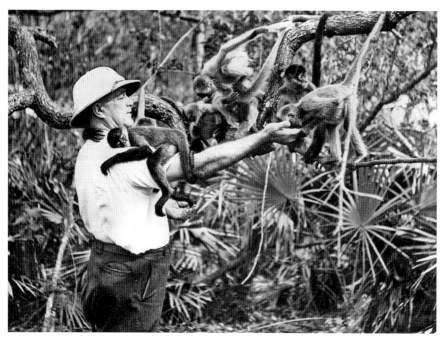

Waldo and the monkeys at McKee Jungle Gardens. *Archive Center, Indian River County Main Library–Ralph W. Sexton Collection.*

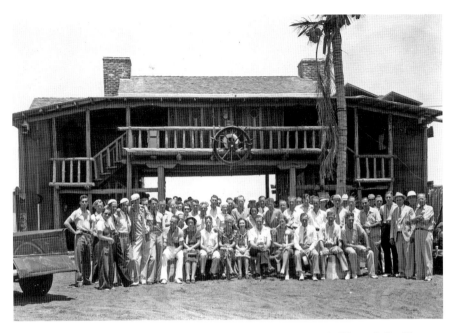

The Old Driftwood Inn, 1940s. *Archive Center, Indian River County Main Library–Indian River County Historical Society Collection.*

breezeway in the center and was intended for use as a private getaway for his family. As time passed, it became a popular gathering place for people, so he decided to convert it into a hotel and resort. He and his wife soon realized that people were always hungry—and his little resort couldn't keep up with demand—so in 1947, he added Waldo's restaurant on the north side of the property. He also opened the Patio Restaurant in Sexton Plaza just to the north of the Driftwood.

Waldo was an avid collector of odd things, and his eccentricities are evident today in all aspects of the place. He would visit estate sales in places like Palm Beach, often purchasing the entire collection. He would then figure out creative ways to add all of the items to the décor of his new resort. Everywhere he went, he would bring things back that he felt were "Florida-related." He would collect wood from abandoned barns, using the rough boards to panel all of the exterior walls of his resort buildings. He even used items that washed up on the beach. Waldo had an obsession with bells and placed hundreds of them at different locations throughout the place. One of the bells was actually from one of Henry Flagler's East Coast Railroad trains. Another bell is from Harriet Beecher Stowe's home.

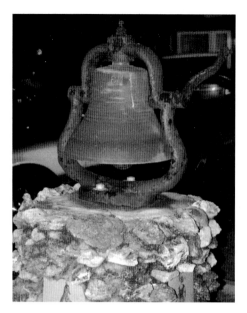

One of Waldo Sexton's bells. *Authors' collection.*

Everywhere you look, there is something interesting to see, from a giant ship's cistern to a massive rusted cannon from a long-submerged Spanish shipwreck. There are painted ceramic tiles from the Dodge Estate in Palm Beach placed at strategic places throughout the property, as well as signs that bear funny, cryptic messages. It's as if Waldo were laughing from some dark corner as you experience his strange sense of humor everywhere. In the center of a large breezeway is a long, roughly hewn wooden table on which the guests were once encouraged to carve their initials. When you sit at the table on one of the crude, sturdy benches, the salty ocean breeze blows through your clothes and hair. It is then that you realize that you are in a truly strange and wonderful place.

# 4
# WALDO'S MOUNTAIN

Waldo Sexton's grand finale was his mountain. A short distance north of the Driftwood Resort, he built a monument that he intended to last for eternity. Utilizing dredge spoil from the adjacent waterway, he fashioned a large mountain that would rival any Mayan construction. The back side of it overlooked Bethel Creek, and the front faced Highway A1A. He cut steps into the side of it and inlaid them with ornately painted tiles gathered from one of his many estate sale collections. On the plateau at the top of his mountain, Waldo placed two chairs and a tall cross. The place became quite an attraction, drawing many curious people who wanted to climb to its peak to marvel at the grand view. As it was being built, many people, including his own family members, didn't realize that Waldo Sexton had a special plan for his mountain. He eventually revealed that, when he passed away, he wanted to be buried under it.

As Waldo grew older, interest in the mountain waned, and it fell into disrepair. Thieves stole many of the beautiful tiles from the stairway, and the property became an eyesore. When Waldo passed away in a retirement home at the age of eighty-two, his family did not honor his wishes, choosing instead to bury him in the family plot. When a hurricane hit the area in the 1970s, the storm surge was so high that it threatened to flood the property. Waldo's son was forced to make a desperate decision. He had his men destroy the mountain and use the fill material from it to shore up the threatened foundation of the Driftwood Inn.

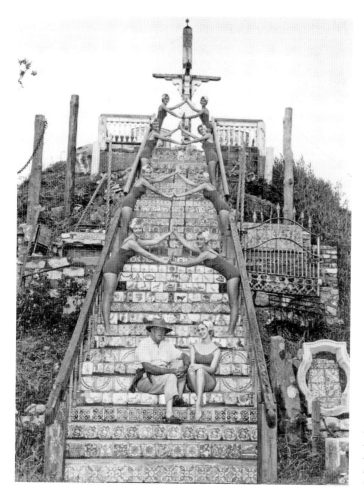

Waldo Sexton's mountain. *Archive Center, Indian River County Main Library–Indian River County Historical Society Collection.*

After this, the fortunes of the property that the mountain originally sat on seemed to take a dark turn. A developer made an attempt to purchase the property, but before the final paperwork was submitted, he suddenly dropped dead of a vicious heart attack. After that, another wealthy investor flew down to view the property for possible purchase. The man liked what he saw and agreed to the deal. On his flight home, the plane crashed, and he was killed. A third person actually did purchase the property but experienced a financial crisis shortly afterward and was forced to declare bankruptcy. Rumors began to swirl that the vengeful spirit of Waldo Sexton was still protecting the property. The weeds grew high, and the deserted lot sat unused for years. A woman then purchased the property, well aware of the reputation and the "curse" that seemed to afflict it. She took it seriously

and decided to take a different tack with the "angry" original owner. As she renovated the restaurant, she tried to stick to Waldo's original quirky style whenever she could. She would start each day by greeting Waldo out loud, embracing his spirit and accepting him as part of the property itself. This seemed to work, because the darkness that had surrounded the place for so long began to lift.

## THE SPIRIT REMAINS

Waldo Sexton is widely believed to have never left the place. Even though he passed away in 1967, many people have seen him make appearances over the years. There is a very popular historical ghost tour there that features the spirit of Waldo as one of its main attractions. One cool April evening, tour guides and owners Thomas Adams and Rebecca Salinas shared some of their well-researched stories with us. Here is one of them:

*Rebecca had finished speaking about the tall mast-like monument erected in front of the original 1937 Driftwood building in Waldo's honor. We walked away toward the table in the breezeway when I noticed that the young married couple didn't follow. Instead, they were frantically trying to remove the wife's sweater. With their actions (practically spinning each other around), I assumed it was a bug on her. They finally got the sweater off and joined us at the table. The wife was visibly shaken. We proceeded with our finale and closing of the tour. The couple got up to leave first and stopped near the monument, where they looked down on the ground and up in the air as if they had lost something. We went over with another visiting Canadian family to offer help. The husband refused and told his wife to tell us what happened. She bluntly said, "No." We all kept insisting she share what had happened, to no avail. The youngest teen member of the Canadian family continued to plead with her. She then relented and began to tell her story. She said that when Rebecca had finished talking about how Waldo loved to be honored, recognized and in the limelight, she felt someone push twice hard on her shoulder with so much force that it almost pushed her down to the ground. She flipped out because her husband was in front of her, and no one was behind her or near enough to have done anything, so they were trying to figure out what it could have been. We hadn't even mentioned to her that this is what will happen from time to time if Waldo really likes*

*you. He'll give a little tap on the shoulder—a kind of "Hey, how you doing" thing. Well, he must have really liked her because he almost pushed her down.*

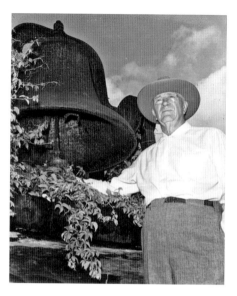

Waldo Sexton. *Archive Center, Indian River County Main Library–Ralph W. Sexton Collection.*

Many people have reported seeing an older man standing just outside of the breezeway near the stairway that descends to the beach. He is wearing a hat and suspenders and has a mischievous smile on his face. When people approach him, he disappears as if made of vapor or dust. Is this the spirit of Waldo Sexton? He loved the place so much that many believe he still hangs out, watching the patrons late at night, longing to join in with their fun and creating mischief, just as he did when he was alive.

Today, the Driftwood Resort is one of the most popular tourist destinations in Vero Beach. The ornately designed rough appearance of the place is a joy to behold. Guests are astonished to see the massive banyan tree that sits at the resort's entrance, with its elaborate, cavern-like root system that is so large you can actually walk inside. There have been several strange things photographed by guests in there, including shadow figures and pale orbs floating in the humid, salty air behind whoever enters. In 1994, the two original buildings were added to the National Register of Historic Places, thus enhancing the place's popularity even more. It is a regular practice for locals to encourage visitors to greet Waldo when they arrive and say goodbye to him when they depart. If you do visit the Driftwood Resort, remember to properly greet the spirit of the eccentric man who created it with these words: "Hello, Waldo!"

# 5

# THE OCEAN GRILL

A short distance north of the Driftwood Resort is a "commons"-style park known as Sexton Plaza. It is a beautiful place located along the ocean and a popular gathering spot for both tourists and natives. On the far eastern end of it is a beachside restaurant called the Ocean Grill. Most people do not know that the place has a somewhat dark history. Originally a hot dog stand built by Waldo Sexton in 1932, it was a well-liked destination for many years when the Driftwood Inn was being established. Much like the Driftwood, it has a waterfront deck that truly exemplifies the Florida experience to all its guests and a crude wooden stairway that descends to the beach. Like the Driftwood Inn, the place was built of barn boards and actual driftwood and decorated with many odd things from the eccentric Waldo's collection, including a colorful stained-glass portrait of a Greek woman holding a bowl of fruit.

The Ocean Grill was a trendy staple for ten years before Waldo decided to make it a full restaurant in late 1941. For some unknown reason, he decided to lease the new restaurant to a German couple that he knew, Russ and Emma Adler. On December 7, the Japanese attacked Pearl Harbor, and the country found itself at war. Most Americans felt a sense of betrayal and outrage at the surprise attack, so attitudes took a sudden change regarding anything German or Japanese. General paranoia and suspicion ruled the day. People stopped coming to the new establishment. Local businessmen stopped doing business with the Adlers. Many locals whispered accusations that the Adlers were actually German spies and somehow giving secret

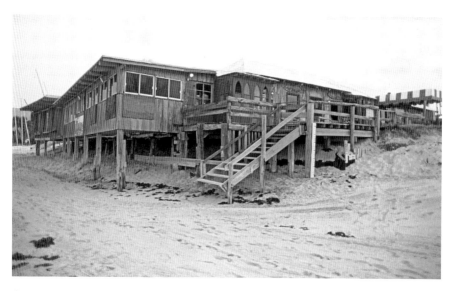

Ocean Grill restaurant at 1050 Sexton Plaza in Vero Beach. *State Archives of Florida, Florida Memory.*

signals to the vicious submarines that cruised the waters very close to Vero Beach. Soon, the restaurant started to suffer hard times. Then, the strangest thing happened. The Adlers vanished, as if lifted from the face of the earth. They had indeed been given a hard time during their stay in Vero, but their abrupt disappearance was still a surprise. What happened to them? Did they finally decide to pack up and leave, disgusted by the futility of their new business venture? Did an angry lynch mob come and take them in the night to exact its own "hometown justice" on them? No one knew. A rumor started to circulate that the Adlers had rowed out to sea in a dory and were then picked up by a German U-boat in the dark of night.

## *U-333:* HIDDEN KILLER IN THE SEA

Within days of the Adlers' disappearance, a terrible event occurred. On May 6, 1942, at 5:43 a.m., a German submarine, *U-333*, sent two torpedoes barreling into the side of an American oil tanker, the USS *Java Arrow*. The ship's location was eight miles east of Vero Beach. Two officers were killed in the shuddering blasts, and forty-five panicked sailors abandoned the ship in lifeboats. The black cloud was visible in the distance, and people could only

surmise what it was. Miraculously, the heavily damaged ship did not sink and was later repaired and returned to duty.

A few hours later, at 9:35 a.m., *U-333* struck again, this time a short distance to the south, near Fort Pierce. It sent a torpedo into the port side of a Dutch merchant ship, the *Amazone*, this time with more deadly efficiency. This vessel had been carrying a shipment of coffee and oil and sank to the bottom within two minutes. Fourteen seamen were killed almost instantly. Eleven were later rescued by the submarine chaser USS *PC-484*.

*U-333* had not yet finished its reign of terror on the Treasure Coast. At 11:25 p.m., an unarmed, unescorted American tanker, the *Halsey*, was cruising northward in the waters east of the St. Lucie Inlet. It was headed to New York from Corpus Christi, Texas, with a hold full of naphtha crude and heating oil. It was a peaceful night, with fairly calm seas. The captain and crew were tense and on guard because of the two attacks earlier that day. The evening's tranquility was soon interrupted by a telltale thud and muffled explosion, followed by the sickening lurch of the huge 7,088-ton vessel. The sailors on board knew that they had been hit by a German torpedo launched by a determined unseen enemy that was hidden from view in the depths of the sea. This was followed by another explosion, causing the ship to list even

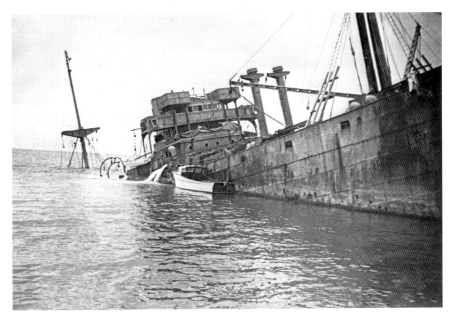

Tanker *Gulfland* burning in water. Hobe Sound, Florida, 1942. *State Archives of Florida, Florida Memory.*

more. The *Halsey* had sustained a sixty-foot gash that had been torn in its hull. The eighty thousand barrels of oil caught fire, producing choking black clouds of asphyxiating smoke. Somehow, the entire crew of thirty-two men escaped in lifeboats before the *Halsey* exploded, ripped in two and headed to the bottom forever.

Very few people actually know of the immense impact of World War II on Treasure Coast beaches. In 1942, the seas off the coast were crawling with sea devils, waiting to scuttle any American ships they could. It was a terrifying, trying time for both residents and military personnel alike. The local press, most likely prompted by the military, did not report on many of the submarine attacks to prevent panic in the population. Waldo Sexton, ever the entrepreneur, turned the Ocean Grill into an officers' club for the nearby naval base at today's Dodger Town.

Was the timing of these vicious attacks a coincidence? Were the Adlers really German spies? If so, had their covert intelligence work paid off? Were their moldering bodies resting in some unmarked, sandy grave somewhere in the wilderness west of town, the nooses still tight around their necks? No one will ever know. What do you think?

## Mobsters Move In

After the war ended, the Ocean Grill came under new ownership. Rumors began to fly that certain members of the Chicago mafia had chosen the place for a hangout. Their reputation followed them wherever they went, so the facts were soon confirmed. Locals avoided the place during those years, fearful of the murderous reputations of the gangsters. How many unfortunate souls were "taken for a boat ride" during those years, never to return? Are any of those lost souls still wandering the beach at night? The mobsters' stint at the Ocean Grill only lasted a short time. They were soon forced out, and a retired sheriff from Illinois took over ownership. The place is now extremely well run by the second generation of the Replogle family. With all of the wild things that have happened over the years under its roughly hewn roof, there is no doubt that the Ocean Grill still has many spirits that cling to it.

# FORT PIERCE

# 6

# SUNRISE CITY

Fort Pierce, Florida, is one of the oldest cities on the Treasure Coast and has been called the hub of St. Lucie County for over one hundred years. It is also known as the "Sunrise City." With miles of riverfront and ocean coastline, Fort Pierce has been a mecca for boaters and fishermen for its entire existence. The city proper lies along the Indian River Lagoon Estuary, a body of water that is home to thousands of varieties of native fish and sea plants. For many years, various parts of Fort Pierce have suffered from deterioration and neglect, but the city has recently undergone a sustained period of resurgence and restoration and now boasts a beautiful historic waterfront district that is always sure to conjure up memories of old Florida. What many don't realize is that Fort Pierce is also home to much paranormal activity and strange goings-on.

In the early twentieth century, the city of Fort Pierce was a bustling railroad, fishing and cattle town with a Wild West feel. Thousands of pounds of fish were caught monthly and brought to the waterfront docks, where they were then transported both north and south by the Florida East Coast (FEC) Railway. Life for the first pioneers was a tough one, with few amenities. Heat and mosquitoes were a constant bother, and long mosquito switches hung by every door. The insects traveled in black swarms and were so thick that they could strangle cows grazing in fields. Clouds of smoke poured from iron smudge pots filled with rags dusted with insect powder. Air conditioning was still a far-off luxury and would not be utilized in the pioneer town for many years. There was also the

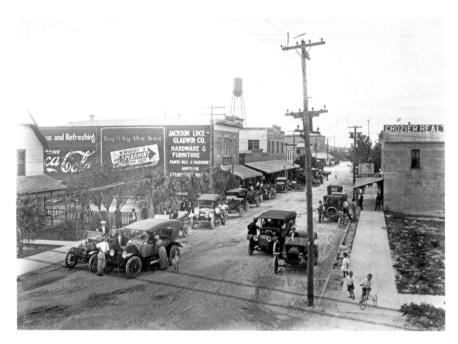

Second Street in Fort Pierce in the early twentieth century. *State Archives of Florida, Florida Memory.*

ever-present threat of summer storms and hurricanes. Life in pioneer Fort Pierce was indeed challenging.

As the years passed, both cattle ranching and the fishing business began to take off. The Indian River estuary was indeed vast, stretching all the way from Fort Pierce Inlet south to Jupiter Inlet. The fickle, limited openings from the sea were small enough to prevent large predatory fish from coming in, so there was a huge population of marketable fish species to be harvested by the enterprising locals. The business of tourism was steadily growing as well, with many Yankees flocking to southeast Florida to enjoy the seemingly endless supply of sunshine. The well-to-do locals of Fort Pierce began to crave more cultural enterprises.

# THE SUNRISE THEATRE

In the newly revitalized downtown area of Fort Pierce, there is an intriguing building that has withstood the test of time. The historic Sunrise Theatre has been there for over ninety-five years. It is Mediterranean in appearance and has the retro look of a 1920s venue. It now hosts some of the most popular acts in the country and is a wonderful addition to the newly revitalized downtown area. It is also rumored to be haunted.

In the early 1920s, there was a very successful local business owner named Rupert Koblegard who wanted to invest in something that would benefit the city that he loved and saw so much potential in. He made an impassioned appeal to the new town council to come up with ideas to bring more culture and civilization to the rural cow town. The council voted, making the joint decision to build something that would entice more people to the downtown area: a theater. Koblegard hired the services of an architect he knew, and together they came up with the design of the largest—and most ornately decorated—public assembly venue in the entire region. In 1923, the Sunrise Theatre opened its doors to great fanfare. There was a large parade to celebrate the debut, and the press played up the event as if it were the dawn of a new era. They even showed a new moving picture on the screen: *The Vagabond*, starring Charlie Chaplin. It was the most significant event to happen in the rural town and seemed to exemplify the growth of the entire area. The Fort Pierce Band played a tribute, and there was great celebrating up and down the streets.

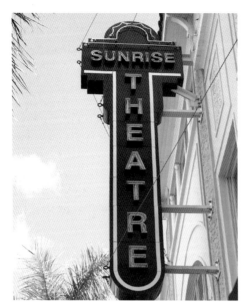

*Left*: Sunrise Theatre sign. *Authors' collection.*

*Below*: Sunrise Theatre front view. Fort Pierce, Florida. *Authors' collection.*

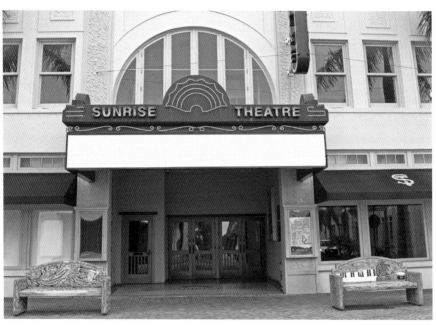

For many years afterward, the Sunrise was the gathering place for all kinds of the best talent of the era. Cowboy star Tom Mix performed there with his sidekick, Tony the Wonder Horse. Sally Rand made an appearance with her provocative fan dancing. Everything was grand for many years at

the new venue, and it seemed that the good times would never stop. Every night on the weekends, one could hear the cheers and applause of hundreds of people as they watched the many shows that made the circuit through town. When the Great Depression hit, the Sunrise barely skipped a beat, offering the temporary solace of great entertainment from the dismal facts of reality. When World War II started, the nearby navy base provided plenty of military clientele for the place. Fort Pierce hummed with activity, and there seemed to be no end in sight. There was so much activity and excessive drinking around the theater that crazy things often happened, like fights between servicemen over the few women available. There was even a wild rumor that some German U-boat crewmen snuck ashore and went to see a movie at the Sunrise.

## Neglect and Decay

As time passed, the limelight began to fade for the Sunrise Theatre, thanks to development in western St. Lucie County and the opening of Interstate 95. The downtown area of Fort Pierce experienced a downturn that persisted for several years, with increased crime and neglect. People stopped visiting the blighted area, and the Sunrise was nearly forgotten. In 1983, the Sunrise Theatre closed its doors for good. People were just not interested in going to an old, out-of-date venue in a rough part of town. It seemed that the place had outlived its usefulness. It was during this period that rumors began to swirl that the old building was haunted. Several people saw odd, opaque shapes in the windows, and knocking sounds could be heard coming from within its old walls.

## Rebirth

### Spirits Awaken

In 2006, the City of Fort Pierce began a million-dollar renovation of the building. The downtown area began to experience a resurgence in interest, with many shops opening up to tourists wanting to be near the water. Contractors gutted the building and began the modernization process. As

construction went on, many of the workers involved began to report strange noises and things moving about in the building. Word of this got out, and the owners were soon approached by a paranormal group to do an investigation. As soon as the building process concluded, the group was allowed to set up its equipment. During the investigation, the team experienced many things that would indicate the presence of paranormal activity, such as sudden battery drainage on all of its equipment, doors opening and closing by themselves and strange knocking sounds in the walls. It is widely believed that the spirit that haunts the building is that of Rupert Koblegard and he is watching over the wonderful theater that he built so many years ago. The investigators concluded that whatever spirit is there means no harm and simply wants to make his or her presence known. It's easy to believe that the vibrant entertainment that is there on a regular basis is a true catalyst for such ghostly activity. What do you think?

# 8

# EMILY LAGOW BELL

According to some of the original pioneers of Fort Pierce, strange spirits have been wandering in the wilderness that surrounds it for a very long time. In her book, *My Pioneer Days in Florida, 1876–1898*, Emily Lagow Bell tells the story of her life and how challenging it was for settlers of the Treasure Coast in the early days. Written in 1928, the book is a vivid view of Florida in the days before development changed it forever. It also reflects on how foreboding the wilderness could be to a young girl, especially on dark nights, when all you could hear were the sounds of insects and the screams of panthers and other wild animals.

In 1876, Bell's family left their cold Illinois home. They were headed for Florida, where her father hoped to find a remedy for his chronic rheumatism in the balmy, tropical air. The young family guided their horse-drawn wagon to Vincennes, Indiana, where they boarded a train headed south. It took nine jostling and achingly slow days to get to Live Oak, Florida. As soon as they arrived, the train suddenly derailed from its tracks. The whole family was terrified as they were roughly bounced around the car. Young Emily banged her head hard against the window. She was not seriously injured, but this was her introduction to the Sunshine State. From there, her family was forced to ride in a livestock car that had no seats all the way to Jacksonville. When they arrived in the rural cow town, they were dusty and exhausted. After a brief rest, they loaded all of their belongings onto a riverboat steamer. They then had a more pleasant journey, cruising all the way down the St. Johns River to Lake Monroe, on the way admiring the

giant oak trees that lined the shoreline. In her writing, Emily commented on the beauty of the Spanish moss that hung from every long, twisting branch. They landed at a place called Enterprise and from there took a wagon pulled by five small horses called "marsh tackies" to the small, very rural community of New Smyrna. There they settled in, and they were very happy, despite the hardships.

Time passed, and young Emily grew into womanhood. Two years after arriving at New Smyrna, she married. Soon, she and her new husband left their home by boat, heading south to start a new life together at the small settlement of Fort Pierce. On the way, they stopped at Titusville, where an old friend of the family greeted them warmly. That first night, Emily and her husband had a lot of fun at an impromptu square dance, and the fiddle music whipped them all into excitement and hilarity. Later, as they sat around the campfire, the old man told a ghost story of an actual haunting that many reputable people in the area claimed was true. He told her of folks being awakened in the night by the sounds of many horses with heavy shoes riding through the trees near the house. They then heard the clanking of great chains and the sounds of boats being pulled up onto the shore. Then came the whispering voices of what sounded like soldiers clambering out of the boats. When the frightened residents ran out of their houses into the night to see if they were being invaded by an army, they found nothing there but the buzzing of insects in the steamy night air. They would shake their heads as they went back into the safety of indoors, only to hear the noises again later that night, after it had grown quiet and still again. This story made young Emily nervous and a little frightened. The wilderness was intimidating, and the spooky story seemed real enough to her. Little did she know that it would not be the last time she heard it.

Early Florida life was very trying indeed for the young couple. In her book, Emily describes the first house she and her husband lived in:

*We lived in the home of my mother-in-law until October, then my husband decided to build us a palmetto house, and it was a large, nice house. As we had taken a homestead that adjoined his father, we had to live on it, but couldn't get no windows or doors, or even boards for the floor. We had two windows and put sand-fly netting on them and put an old canvas sail on the doors. We kept the house dark because the mosquitoes were thick and the horseflies almost solid. I have scraped the horseflies off the window and would get three quarts at a time. They tortured the cows until we have had*

*to build large smudges to keep them from killing the poor things, and in the woods many were killed. They were thicker than a swarm of bees.*

Emily also wrote that she killed nine large rattlesnakes on the property during the first six months that they lived there. She shared that she found the screams of panthers and bobcats terrifying and hated the skunks that often wandered into the house. On the darkest of nights in the wilderness, her young imagination got the best of her, and she often woke up covered in sweat.

## Phantom Riders in the Night

*We were sleeping sound, and it was one of the most beautiful moonlight nights and not a ripple on the water, and the silvery sheen glistened, only to be seen on the beautiful Indian River. Not a person nearer than one mile, when all at once I found myself sitting up in bed shaking my husband, saying "Indians! Indians!" He listened. Nothing moved. He said "You were dreaming." I said "No, be still."*

*We listened and it was after one o'clock, and then the sounds, like horses with shoes running around and around the house, and the clanking of chains. I jumped up, went to one door, he to the other, and everything ceased, not a leaf stirred. We went to bed again, and it would commence again. It would only last a short time. Then we would hear a rowboat land at our dock and throw the oars into the boat, and it was as plain as it was as if we were there in the boat. Well, this was five or six times a year, for the first three years we lived there. It was spooky!*

Who were the strange, phantom horsemen who frightened Emily and her husband that night? Well, a clue is found in her story. A few years later, in the year 1880, a gentleman stranger came by their house. He told Emily and her husband that he had recently visited the site of old Fort Pierce a short distance away. He told the young couple of Colonel Benjamin K. Pierce and his soldiers, who had been in the area back in 1837 during the Second Seminole War. They had erected a large palmetto blockhouse fort next to a giant old Indian burial mound located right on the river. The fort itself had long since burned to the ground, but the Bells' visitor had found Minié and musket balls and was interested in any information the locals

had. As he talked about the many soldiers on horseback, Emily Bell must have felt goose bumps. She then blurted out the story of the ghostly horses and clanking chains in the night. The man looked at her as she spoke, a thoughtful expression on his face. He then asked her if she minded if he looked around the property a bit. She and her husband consented, and soon the man was digging holes in the weedy yard.

The man worked hard, probing around in several different areas. He soon grew excited as he found something buried in the sand. The young couple watched as he carefully dug around and then reached down to pick up his discovery. He then hurried over to Emily, a wide smile on his face. She looked down into two empty, sand-encrusted eye sockets. In the man's large hand was a dirty human skull. The young couple was stunned. Emily asked the man if it was the skull of an Indian, because many people had found such things along the water. He shook his head and told her that it was not that of an Indian. He explained that there had been a skirmish there involving the soldiers, and the bones he had found were the reason that they were being haunted. The stranger then found several more skulls, which he took with him when he left. Emily Lagow Bell had found her ghost.

# The Sea Monster

In her book, Emily tells another strange story. The whole family was on a boat trip to Lake Worth to search for her wayward sister, who had run off with a local boy. When they arrived at Jupiter Inlet, her father left Emily and the other children so that he, Emily's husband and her mother could continue on to Lake Worth by foot. This was a long, arduous walk of over eight miles and may have been a blessing for Emily's sister and her beau. Her father would have killed the boy on sight, so a long hike may have been what he needed to cool down a bit. As they neared their destination, her mother lagged behind. As she made her way through the thick vegetation toward the river, she saw some movement in the trees ahead of her. This is Emily's account of what her mother saw that day:

*Looking up, about twenty feet away, she could see something slowly dragging along. She called and called. Dad looked around. She beckoned, but he shook his head, but she sat down then. He thought she was hurt, so hurried back. She pointed toward it. They saw what it was. It was a sea serpent*

*of some description. Well, it was green and black and a yellowish mingled color, and they watched it crawl to the sea. It raised its head and looked all around until it turned their way. Then they said it looked like a human face. It stood up about three or four feet. They measured to where it's tail was and to where the head was and it was about thirty feet long and looked like the size of a small nail keg.*

*They went on over and could see the trail. Told Mr. Brown and Moore of it. They said it had been seen about twice a year and the Indians were superstitious and would neither kill or try to capture it.*

*So in 1927 one has been seen over at Surfside beach twice. Some men came over to Fort Pierce to get guns to kill it with, but when they got back it was gone. Don't think it the same one as that was 42 years ago.*

What had the woman seen? Where had this grotesque creature come from? More than one person saw it and had sworn that the creature with the "human face" did indeed exist. Was it a misplaced sea animal from some deep grotto of the sea, or was it something else? Perhaps it was a spirit from another world, conjured by the Ais medicine men. No one will ever know. It will just remain another haunting mystery from the Treasure Coast.

# 9

# CRESTHAVEN

## THE BOSTON HOUSE

As you make your way along Indian River Drive toward the southern end of the historic city of Fort Pierce, Florida, you will pass a very interesting building on your right side. Far from the average South Florida structure, it will definitely catch your eye because of its interesting blend of Georgian and Neoclassical architecture. Built of red brick and decorated with finely crafted wooden façades, Cresthaven, better known as the Boston House, is one of the most significant historical buildings in Fort Pierce. It looks more like a government office in Washington, D.C., than a private residence.

The Boston House was erected in 1909 by a man named William Turpin Jones, an engineer on Henry Flagler's Florida East Coast railroad. He came to St. Augustine, Florida, in 1892 as a young machinist. There, his diligence and quality workmanship caught the eye of Henry Flagler himself, and the two men became personal friends. In 1900, Jones received a promotion. While serving as engineer of the railroad between Jacksonville and Key West, Jones miraculously survived two terrible train accidents. One involved some live explosives that had been left on the tracks. When the train hit the dynamite, it exploded. Jones was severely injured and awarded $6,000 in compensation. This he used to build a house, which he christened Cresthaven. The second accident happened when an important message was not delivered and two locomotives collided head-on. Jones barely escaped with his life by jumping into a canal just before impact.

In 1913, Jones retired from the FEC railroad to open an orange grove and dabble in real estate. The very same year, Jones's seventeen-year-old

W.T. Jones home, early 1900s. *State Archives of Florida, Florida Memory.*

son, Fred, became engaged to a young woman named Ada Daniels. After a wonderful party at Cresthaven, young Fred took his bride-to-be out for a moonlight ride on his motorcycle. They were joined by one of Fred's close friends, Raymond Saunders, on another motorcycle with Ada's sister, Nola, on the back. Something went awry on the dark road, and the two motorcycles collided. Three of them were badly injured, and young Nola Daniels was killed.

In 1915, Jones became the sheriff of St. Lucie County. He served in this position for five years until resigning in 1920 because of the position's low pay. Tragedy hit the family again. In 1918, Jones's ten-year-old son, Clifford, and a nine-year-old playmate, William Fee, were frolicking in the living room of the great house. Somehow, the young boys had gotten their hands on a loaded pistol and were playing with it when the gun discharged, hitting young William in the abdomen. The unfortunate child later lost his life from the wound. It began to seem as if tragedy was imbedded in the very structure of the house.

In the early 1920s, Jones went back to work for the railroad. A few years later, the Great Depression hit South Florida with a vengeance—many years

before it hit the rest of the country. This was due to major hurricanes that ravaged the area in 1926 and 1928, the latter killing over three thousand people on the southern end of Lake Okeechobee. Jones was forced to borrow money to cover his investments and lost Cresthaven to a man named Irving C. Whitney. Whitney died soon after, leaving the house to his sister, Rose P. Whitney. In the early 1930s, Rose and her elderly sister took up residence in the Boston House, as it was then called, probably because of the building's proximity to Boston Avenue. Both sisters would spend the rest of their lives in the house and die within its walls from long, drawn-out illnesses. The house then went up for public auction to sell all of the spinster sisters' belongings. Most items were sold, but the house itself was not. After a zoning change was passed deeming the property "commercial," an engineering firm took up residence there. Wood, Beard and Associates stayed in the house until 1976 before selling it again as a private home.

The new residents, Leonard Cottem and his wife, Diane, ran the place as a bed-and-breakfast. They touted the place as being haunted and apparently had some interest in spiritualism and the occult. They reportedly used the upstairs attic for various activities, including séances. Many believe that these practices may have stirred up the paranormal activity that later became rampant in the house. There is one very well-known legend that seems to have withstood many years.

When the Boston House was being used as a bed-and-breakfast, a young family came to stay there. Aleacon Perkins, her husband and their young son, Tim, rented a room at the inn, excited to have a fishing vacation. She was a beautiful woman with long, flowing red hair. One morning, her husband and young Tim left early to go fishing, leaving Aleacon in the room to relax. There was a severe, unexpected storm that blew in that day, and she became worried. When her husband and Tim did not return when expected, she grew frantic and informed the local authorities. The following morning, they searched the shoreline, finding an overturned boat and the body of her drowned husband. Tim's body was never recovered. The legend goes that on stormy nights, the apparition of a pale woman with long red hair can be seen in the third-story window, gazing out toward the sea, waiting eternally for her lost family members.

More than a few psychic mediums were invited into the house, most of whom reportedly made contact with Aleacon. There are other hauntings that were recorded in the house. People have heard crazy, maniacal laughter in the rooms, and there have been sightings of ghostly Indians

Boston House. *Authors' collection.*

sitting on the front lawn. Several of the mediums also mentioned making contact with a wailing woman who was in deep mourning over someone who had been hanged. Employees of the latest tenants of the building, a law firm, have reported strange goings-on since they moved in. Things are moved around, windows are opened when no one is there and doors

If you look closely, you can see a large orb in the upper-center window. Boston House, Fort Pierce, Florida. *Authors' collection.*

are mysteriously unlocked. Many have sensed a strange presence in the house and complained of smelling fragrant perfume in the still air of the old house.

The Boston House is located at 239 South Indian River Drive in Fort Pierce. There are no tours of the house available. It stands proudly as a preserved monument to the past. Maybe someday the spirit of Aleacon Perkins will be reunited with her long-lost family. For now, she still watches hopefully.

# OLD FORT PARK

As you cruise along beautiful Indian River Drive, you will be stunned by the beauty of the river and the historic homes perched on the knolls facing the water. Just past the Fort Pierce city limit sign, you will see another one that reads "Old Fort Park." If you slow down and turn your vehicle into the driveway, you will be amazed as the realization sinks in of what it is you are seeing. At first glance, it almost looks natural, but as you inspect it you realize that it is something much more. It stands more than twenty feet higher than the land around it and is several hundred feet around. What you are looking at is an ancient burial mound of the Ais Indians, the original inhabitants of the area.

As discussed in the first chapter of this book, before and after European contact in the early sixteenth century, the area now known as the Treasure Coast was already home to hundreds—possibly thousands—of native people. They were so numerous that the first Spanish governor of the territory known as La Florida stated that he "had never seen so many Indians." Evidence of their existence is found all the way up the coast in the form of middens and burial mounds. As discussed in earlier chapters, a midden is essentially made up of the trash and refuse of the ancient people. These swelled formations consisted of empty, broken shells, bird bones and broken pottery shards. It is widely believed that the Indians may have intentionally piled this material high in the air to create good places on which to construct their sacred buildings. The mounds were above the frequent flood levels from storms—sometimes

Stone stairway on the Fort Pierce Mound. Fort Pierce, Florida. *Authors' collection.*

above the mosquitoes—and they were good vantage points to look out for ships or approaching intruders. Many believe that the Ais used the raised areas for worship, bringing them closer to the heavens. Numerous old "shell rock" roadbeds all over the entire state were originally mined from Indian midden shell material.

Then, there were the burial mounds, such as the one in Old Fort Park. A burial mound is mostly made up of sand from the river used to cover the bodies. Digging graves was simply not practical in the limestone-encrusted wet environment of the Treasure Coast waterfront. The deceased were treated with the utmost respect and ceremony. Here is an account of a funeral ceremony of the Timucua, a tribe from just north of the land of the Ais, as recorded by Theodore De Bry:

> *When a chief from that country dies, he is buried with great solemnity. The cup from which he used to drink is placed on his tomb which is surrounded by arrows stuck in the ground. His subjects mourn him for three days and three nights without eating or drinking. All his friends do the same, and in testimony of the affection they held for the deceased, both men and women cut off more than half their hair. During the next six moons, women specially chosen for the task lament the death of their king at dawn, midday and twilight with great howls. All the king's personal property is carried to his house where it is burnt. They do the same thing for priests.*

Many believe that the Ais and their ancestors lived along the Treasure Coast for as many as twelve thousand years. As you stand on top of the mound and look out over the expanse of the river, you can allow yourself to let the thousands of years fall away, and you are transported to a time before the roads, automobiles and condominiums overtook the landscape. If you are very still, you can almost hear the women chattering by the river and the splashing of the children playing in the water. If you listen hard enough, you can hear the haunted chanting of the shamans as they perform their moonlight rituals. The residual emotions experienced over all this time are still present in the place. The spirits of the dead are soaked into the very ground itself.

Not only does this little place have the Indian burial mound, but it is also the location of one of the most significant historical sites on the Treasure Coast. The original Fort Pierce was built just to the north of the mound during the Second Seminole War, in the late 1830s. When the First Artillery Regiment, led by Colonel Benjamin K. Pierce, sailed up the river looking for a good place to build a fort, the soldiers found the massive Indian mound and its natural freshwater spring. It seems that the long-dead Ais people had already chosen the best spot to settle. The outpost was erected as a series of palmetto log blockhouses, complete with a surrounding fence, outbuildings and a large parade ground. One of the last soldiers to serve in

Ceremonies at the death of a chief or priest, 1591. *State Archives of Florida, Florida Memory.*

the fort was William Tecumseh Sherman, then a much younger man than in his more famous days during the Civil War. Fort Pierce was only used for four years before it was abandoned. Not a trace of it is left, but the Ais burial mound remains.

Many paranormal investigations have been performed near the site. Sightings of full-body apparitions moving slowly through the trees have been reported, as have strange sounds in the darkness. Investigators have experienced unexplained battery drains on their equipment. On many photographs and videos that have been taken over the years, strange white orbs flit and dive through the air. Many people have had the strange sensation of being touched or scratched by some unseen entity. The Ais Indians reportedly buried their dead in the sitting position, with part of the seat of their canoes under them. Why did they do this? Could it be so they could easily row their spirits through the waters of the afterworld? Images of beings in a seated position have been captured near the mound.

My suggestion would be to visit this sacred haunted site for yourself. Always remember to treat it with the utmost respect and dignity, for it is the

Fort Pierce Indian mound, Fort Pierce, Florida. *Authors' collection.*

resting place of countless Native Americans, as well as U.S. soldiers who may have perished there in the hospital for many reasons, from sickness to injury from fighting the defiant Seminole Indians. Come experience the magic and beauty of Old Fort Pierce Park.

# PORT ST. LUCIE

# 11

# THE DEVIL'S TREE

On quiet October nights, the cool breeze whispers gently through the moss-covered boughs of the great oak trees. It is a beautiful place—one of the last surviving patches of oak forest in the sprawling city of Port St. Lucie, Florida. Oak Hammock Park is a wonderful respite from the busy, bustling roadways, strip malls and housing developments that have taken the place of the once vast flatwood forests and seemingly unending wetlands of southeastern Florida.

There is one thing that separates the park from others like it: the place is known as one of the most haunted locations on the Treasure Coast. This dark reputation is based on an urban legend that has endured for many years. Near the center of the forest is one tall, thick oak that is well over 150 years old, and it has a dark history and a name to go along with it. It is known as the Devil's Tree.

## THE STORY

In early January 1973, a Martin County sheriff's deputy named Gerard John Schaefer stopped to question two young girls, Pamela Sue Wells and Nancy Ellen Trotter, who were hitchhiking in the Stuart area. He showed them his badge and got them into his patrol car. He then drove them to a remote area nearby and forced them into the dark woods at gunpoint.

The Devil's Tree at Oak Hammock Park, Port St. Lucie, Florida. *Authors' collection.*

There, he tied them both to a tree branch with nooses around their necks so that their feet were up on some exposed roots. He threatened their lives and told them that if they moved they would fall and be strangled. Schaefer then got a call on his radio and left. The two terrified girls desperately struggled with the ropes for hours. Miraculously, one of them was able to loosen the

knots on her wrists enough to work herself free. She cut her friend's bonds, and the two girls were soon stumbling through the woods in the darkness. They made their way to the nearest police station, which just happened to be Schaefer's workplace. The two hysterical girls then told the sheriff what had happened to them.

Schaefer went back to the site to finish his dastardly deed and was shocked to find the girls gone. He radioed the sheriff, nervously telling him that he had made a bad mistake and had merely been trying to "teach the girls a lesson about never hitchhiking again." The sheriff did not believe him, and Schaefer was consequently stripped of his badge and jailed for assault.

Gerard John Schaefer was released a short time later, after posting the initial bail on the assault charge. Two months later, he abducted two more girls in Martin County, Susan Place and Georgia Jessup. He tied them both to a tree branch as he had before but this time followed through, torturing and killing them both. He then disposed of their bodies on nearby remote Hutchinson Island.

Later that year, he was found guilty of aggravated assault on the two girls who had escaped and sentenced to one year in prison. Shortly after his incarceration, the decomposed bodies of Susan Place and Georgia Jessup were found on Hutchinson Island. An investigation ensued, and when police searched Schaefer's home, they found some evidence that was both disturbing and damning. They found diaries that he had written describing the horrible things he had done to the girls in great detail. In his writings, Schaefer revealed a hatred and fear of women that was proof of his deep psychological issues. The investigators also found personal possessions of the victims, such as jewelry and even teeth, from at least eight different girls who had gone missing in recent years.

In October 1973, Gerard John Schaefer was found guilty of murder in the first degree of Susan Place and Georgia Jessup and given two consecutive life sentences. Law enforcement officials soon learned that he was most likely connected to the disappearances of over thirty women in the South Florida area, including two found near what is now Oak Hammock Park in Port St. Lucie. The remains of Collette Goodenough and Barbara Ann Wilcox were found by fishermen about three hundred yards from the Devil's Tree's spreading limbs.

In prison, Schaefer was boastful and arrogant:

> *Doing doubles is far more difficult than doing singles, but on the other hand it also puts one in a position to have twice as much fun. There can be some*

Gerard John Schaefer's mug shot after his arrest. *Public domain.*

*lively discussions about which of the victims will get to be killed first. When you have a pair of teenaged bimbolinas bound hand and foot and ready for a session with the skinning knife, neither one of the little devils wants to be the one to go first. And they don't mind telling you quickly why their best friend should be the one to die.*

On December 3, 1995, after serving over twenty years of his two life sentences, Gerard John Schaefer was stabbed to death in prison by a fellow lifer inmate who hated him and had nothing to lose.

## INFAMOUS HAUNTED SITE

After the grisly events that occurred at what is now Oak Hammock Park became public, the Devil's Tree became infamous. It was the late 1970s, and the place was still overgrown and remote. Deviant groups were drawn to the place because of the bizarre nature of the killings, and it was said that devil worship was performed late at night under the tree's branches. People claimed that the place was possessed and they could hear the screams of the girls at night. Even the restrooms located at the entrance of the park were said to be haunted by the dead girls. For years, hikers and young lovers reported being chased out of the forest by dark, hooded figures.

By 1993, the rumors of dark doings became so well known that a local pastor decided to intervene and performed an exorcism at the Devil's Tree. After performing the ritual, he and his group then erected a wooden cross and imbedded it at the base of the massive oak as protection against evil spirits. When one of the group members returned eight months later,

Close-up of the trunk of the Devil's Tree. *Authors' collection.*

he was horrified to see that the cross had been pulled out and placed upside down.

In 2000, St. Lucie County decided to turn the place into a park. In order to dispel any future problems, contracted workers headed into the forest with chainsaws to cut the controversial tree down. When they began

to commence work, they were frustrated to discover that their chainsaws would not start. Determined to finish the task, they tried an old-fashioned two-man handsaw. This did not work either. The steel teeth of the blades broke off when they tried to cut the ancient wood. They then gave up and decided to let the tree live.

We have visited the place ourselves. It is strangely serene there, and one gets a sense that the underlying tragedy that occurred there is hidden by day. Our suggestion is that you visit the site yourself and see what you think.

# GHOST SHIP IN THE ST. LUCIE RIVER

They say that legends are born from the seeds of truth. If this is true, then there must have been countless colorful and tragic events that occurred throughout the history of the Treasure Coast to have spawned so many great tales. One such legend involves a pirate whose dark, violent reputation is well known on both the east and west coasts of Florida. Black Caesar, as he was known to his men, was one of the fiercest and most cunning of the buccaneers during the "golden age of piracy."

According to this legend, the infamous pirate was a frequent visitor to the Treasure Coast, often guiding his ship into the St. Lucie Inlet late at night to take advantage of the winding stretches of mangrove-lined waterways, which provided an excellent hiding place from the Spanish. He and his crew of rough outcasts would then prey on ships traveling north along the Gulf Stream from Cuba as they moved up the Florida Channel toward Spain.

According to the legend, Black Caesar was originally a successful war chief on the African coast. He was very intelligent and knew how to get men to follow him. His high intellect—not to mention his immense stature and physique—not only helped to establish him as a natural leader, but it also enabled him to elude the slave traders for many years. He was captured only by an act of deception. A devious trader made a promise of great treasure for Caesar and his group if they would only come on board his ship to help carry it. When Caesar and around twenty of his men came on board, they were immediately taken prisoner. They were then chained below deck as the ship made its way west across the great Atlantic. Along the way, Caesar befriended one of the trader's crewmen. He used his great powers of communication

to form an alliance with the sailor, who went so far as to promise to help the war chief escape when the opportunity arose. As the slave ship sailed along the coast of Florida, the sea flattened out into great rolling swells, and the air pressure dropped. The slavers were soon confronted with a savage hurricane that rocked and battered the ship with driving rain and shrieking winds. Caesar's ally took the opportunity to sneak below deck and free him. The two men then stole some weapons and went after the captain, who was frantically trying to save his vessel from the storm. Terrified by the huge, imposing black man who now had him cornered and threatened his life, he quickly surrendered. The two fugitives then loaded a longboat with stolen supplies, tools and weapons and pushed off into the dark, forbidding ocean toward shore, braving the high waves and howling winds. Miraculously, they made it to the beach unharmed. The same could not be said for the slave ship, which was lost with all hands in the gale sometime before dawn.

Caesar and the sailor established a camp near the shoreline and befriended the local Indians, who hated the Spanish and now feared this huge black man who had come in from the sea. Desperate to survive, the two devised a plan. They watched for passing ships and then rowed out to them, pretending to be castaways. When the unsuspecting crew took them aboard, they would pull out their hidden weapons and take hostages, threatening to kill them and everyone aboard and sink the ship if they didn't comply. This technique worked successfully for them for many years, and they began to increase their numbers, often by adopting the disgruntled crew members of prize ships. It seemed that—to some—a life of piracy was much more attractive than the abuse, rigors and low pay of merchant sailor life.

Life was good until Caesar and his partner had a disagreement over a female captive. There was a brutal altercation in which the sailor was killed. Black Caesar was now the sole leader of the group. Over the ensuing years, he grew more powerful and increased the scope of his attacks, developing methods of luring ships onto the treacherous shoals in key spots along the Atlantic coast all the way to the Florida Keys. He would use lanterns to lure unsuspecting ships coming from Cuba close to shore, where they would grind their hulls on the reef and become paralyzed, often sinking completely. Black Caesar and his men would then rush out of the trees to massacre all of the sailors and claim anything of value. His main base was said to be located on Old Rhodes Key, near Biscayne Bay, where it is said that he had an entire island set aside to house his captives. He did this in the hope that he could, in the future, ransom the poor souls back to their families. The legend also says that he kept a harem of female slaves for his own personal enjoyment.

Somewhere along the line, Black Caesar met the famous pirate Blackbeard, who also preyed on ships along the Florida coast. This meeting may have occurred as a result of the 1715 fleet disaster, in which eleven Spanish treasure ships were lost in one terrible storm along the Treasure Coast. This event drew pirates from all over the Caribbean like flies. It is said that the two pirates formed an alliance and Black Caesar left his empire at Biscayne Bay to join Blackbeard's crew aboard the *Queen Anne's Revenge* to attack ships along the East Coast, near the colony of North Carolina.

Blackbeard and his fearsome crew were later forced to abandon the *Queen Anne's Revenge* when it ran aground on a shoal just outside Beaufort Inlet. When his replacement ship, the *Adventure*, was attacked by Robert Maynard in 1718, there was a fierce battle, during which Black Caesar may have personally witnessed the gruesome death of his new commander. Blackbeard had told him earlier that, in the event of his death, he was to blow up the ship with several kegs of black powder that were stored below the deck. Before Caesar could do this, he was overpowered by several of Maynard's men and taken prisoner. They took him and several other crew members back to Williamsburg, Virginia, where they were later found guilty and hanged for the crime of piracy.

## WALLACE STEVENS'S ACCOUNT

Below is an article from the *Stuart News* of Thursday, January 9, 1964. It was originally published in the Sunday version of the *Atlanta Journal* on January 25, 1931, by Wallace Stevens, a Stuart resident.

> *DOES BLACK CAESAR'S GHOST SHIP CRUISE ON THE ST. LUCIE? STEVENS SAW "PHANTOM." TOLD STORY IN ATLANTA NEWSPAPER*

> *The* Sunday Magazine *of the* Atlanta Journal *on Jan. 25th, 1931, carried this strange story of how a Stuart resident, Wallace Stevens, son of the founder of the newspaper, saw a strange ghost ship on the St. Lucie. "I saw a phantom ship. I still don't know what it was," he told the Stuart News recently at his home near Okeechobee City. Here is the story.*

> *By Wallace Stevens*

*A ghost ship that sails swiftly over wind-swept, moonlit waters without a stitch of canvas? A ship with every inch of planking and every mast and spar illuminated brightly, yet on which no electric, gas, or kerosene light can be seen?*

*"Impossible," you say.*

*And that was just what I said as I sat there in a crazily rocking skiff looking at it many years ago.*

*The scene was the St. Lucie River near Stuart on the east coast of Florida. Varying from a mile to two miles wide and rolling graceful curves between white sandy beaches lined with palms, the St. Lucie is widely held by many to be the prettiest river in Florida. Ex-president Cleveland found rest and health on its banks after the trials and weariness of his second administration. Many other great and near great men to the nation have been attracted to the beauty of the stream and the wonderful fishing it affords. And according to a legend, it was a favorite for Black Caesar, a notorious pirate of African blood who cruised the Florida coast in the golden days of the Spanish Main.*

*I hadn't heard the legend, though. Then I set out one night in a little skiff with an outboard motor to visit a friend living on the north fork—the river divides just west of the highway ridge going into Stuart. The two branches are known locally as the North and South Forks.*

*I had intended on leaving in the middle of the afternoon, but work had kept me tied up until after dark. When I did get ready to depart, a stiff breeze was blowing in from the southwest, and it looked rather foolhardy to venture out. I knew the waves would be running high as soon as I left the lee of the shore. A half-moon was shining, however, and I decided to risk it.*

*After I got a couple of hundred yards off shore the waves came up to all expectations, slapping against the skiff at a quarterly angle and showering spray across the little boat. My outboard was an old style one that short-circuited when it got wet, and it wasn't long until it started sputtering and finally quit. I slipped it out of the water so it wouldn't drag and got out my oars.*

*The skiff was better balanced when I was rowing than when the engine was pulling the stern down, so I made fair progress over toward Dead Man's Point where the North Fork entered the main river.*

*As I rounded the point and glanced ahead to get my bearings, I noticed a light that marked a fair size ship a mile or so away across the water. I was mildly interested because there were no towns above Stuart on the river and*

*few ships of any size went beyond the bridge. The thing was apparently coming toward me.*

*I turned my back to it and went to rowing. In a few minutes I looked again.*

*The ship had covered over half the distance between us and was close enough then for me to notice its peculiar shape. It was high in the bow and stern like the pictures and models I had seen of old Spanish ships. Yet the bow was not as broad and full and the ship sat lower in the water. And although it only had two masts, it looked faster than the old time prints showed the true Spanish caravels to be.*

*And as I noticed this I wondered, too, that the ship stood out so plainly in the shadowy moonlight. It seemed to glow all over, and every inch from the waterline to the top of the masts was visible, yet there was no direct light to be seen. And I wondered, too, at the progress it was making as it was close enough now to hear the engines if any were running, and yet there wasn't a sound. And there wasn't an inch of canvas spread on the masts. There were no figures on deck, nor any sign of life aboard.*

*The channel for ships of any draft was rather narrow at that point, and I was right in the middle of it. I decided that, regardless of the ship's peculiarities, I had better get out of its way.*

*I swung around to my right and edged over to Dead Man's Point. And I kept edging over. Regardless of how far I swung out of the channel, it seemed that the coming ship was still bearing straight for me, and no great distance off now either. I yelled, but got no answer.*

*Finally, it looked as though the best thing I could do was to get clear out of there and in a hurry. The thing was beginning to assume the proportions of a nightmare. I put all of the strength I had into the oars and shot into the quiet waters behind the point. After landing the skiff between a clump of mangroves, I forced my way through the tangled underbrush that ran out to the water's edge on the point and looked back out over the river.*

*There wasn't a sign of the ship anywhere. The lights of Stuart showed a mile back across the river whence I had come, while the waves danced in empty moonlight as far as I could see up the North Fork.*

*Naturally, I was mystified. I had been nervous, after seeing the ship, about being run down there in the dark. I had been puzzled by the appearance of the craft, but I hadn't been terrified. I now regarded the thing as supernatural. If I had thought of ghosts, or had any fear of them, I wouldn't have landed at Dead Man's Point. I had heard tales of spooky things there, where a group of men had been buried during a battle during a*

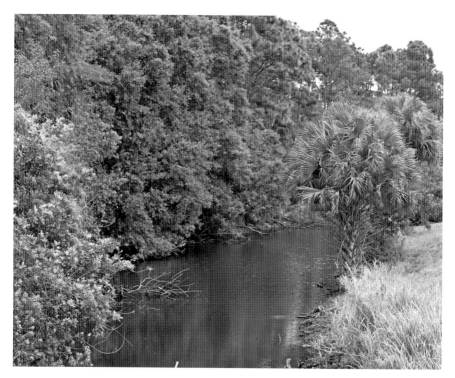

St. Lucie River wilderness. *Authors' collection.*

*drunken orgy at the time of the building of the railroad bridge nearly three decades before. I had stepped across one of the graves in working my way through the underbrush back to the point.*

*Vessels carrying goods to or from Cuba would be decoyed in and wrecked on the reef guarding the narrow beach. Then Caesar and his men would swarm out and murder all survivors before taking what booty they wanted from the stranded merchantmen. According to the stories, there were wild and riotous times on the wave-beaten sands in the old days.*

*It was peculiar that there were no legends of buried treasure in that vicinity. Down in the Florida Keys, where Caesar had similar landing places, there are many tales of hidden gold, and innumerable treasure hunts have been launched by persons varying from small boys to college professors. Occasionally, a story is given wide publicity of small amounts of Spanish gold being found in rocky crevices down there. About ten years ago, a story was published telling of skulls and bones evidently a hundred years old or more being found at a point where Caesar and his crew had their headquarters.*

*But if the black pirate actually buried his treasure on the banks of the St. Lucie, and still cruises there in spirit form to guard it, he certainly hid it well. No Spanish gold has been found in that vicinity, and no one has ever located a map with crosses marking the spot where pieces of eight may be buried.*

# JENSEN BEACH

# TUCKAHOE

## THE LEACH MANSION

In the quaint community known as Jensen Beach, you will find a relaxed world of rustic seafood restaurants, surf shops and bed-and-breakfast hotels adorned with murals of saltwater fish. It's almost as if time has stood still since the 1950s or '60s. If you drive farther south through Jensen Beach along Indian River Drive toward the causeway, you will find yourself looking at a large series of hills on your right-hand side. On the old maritime maps, these were called "Bleech Yards" because of the white sand that covered their peaks. If you look to the left, you will see Indian Riverside Park. Along the water, there is a beautiful white mansion perched high on a hill overlooking the river. This is Tuckahoe.

The first thing you will notice about the place is how it doesn't quite fit in to the typical "Jensen Beach" motif. With its gleaming, arched façades, terraced porches and huge swimming pool, it looks like something from 1930s Hollywood. The building was recently renovated to its current pristine condition, but for many years it sat idle and abandoned. This gave rise to many legends and stories involving the property's history.

## WILLIAM H. RACEY

In the 1850s, the ending of the brief, but bloody, encounter known as the Third Seminole War signaled a land boom on coastal Florida real estate. An

adventurer named William H. Racey visited the Indian River area and liked what he saw, buying up hundreds of acres of land. He especially liked the high mound that overlooked the area, naming it Mount Elizabeth in honor of his mother. His plans were to eventually build a magnificent house on its peak and move into it when he retired.

The mound was actually not a natural formation. It was a fine example of a shell midden, or refuse mound, for the ancient Ais Indians who inhabited the place for thousands of years. It was sixty feet above sea level and towered above everything else around it. The sheer magnitude of the structure seems to emphasize the importance of the place to the Ais. Archaeologists believe that the Ais built their ceremonial houses on top of such middens for many reasons, the most likely being to keep dry during floods. Due to the mound's extreme size and panoramic view of the river, there is also the distinct possibility that the site was used for ritualistic purposes. Racey saw it only as a high place that would get him and his family up above some of the clouds of mosquitoes and into the gentle river breezes.

Before he could put his retirement plan into motion, William H. Racey died in 1874. The property lay vacant for a number of years. A local man, Benjamin Darling, took it upon himself to build a small house at Mount Elizabeth and lived there with his family for ten years, unaware of Racey's previous ownership. He checked the tax records and found a delinquency on the property. Darling frantically tried to raise money to cover the delinquency and purchase the land on which his house sat, but Racey's son, Charles Henry Racey, learned of the unpaid taxes and set his title right. The disappointed Darlings were forced to move north.

Charles Racey decided to move his family to the community then known as Waveland. At that time, the area was so underdeveloped that the southernmost terminus of the Florida East Coast Railway was Titusville. The family had to travel by boat with all of their possessions. When they arrived, Charles set about building a beautiful three-story mansion on top of the mound. It was the grandest house in the area and became a popular gathering place for many social gatherings. The Raceys lived in the house happily for many years, until one dark day in 1923, when a raging fire—most likely started by an unattended gas stove—destroyed the house and everything in it. The neighbors could do nothing and watched the structure burn, the orange flames visible for many miles through the dark night. One cannot help but ask: had the natives who lived there for thousands of years taken their revenge?

## THE LEACHES

The Raceys apparently had enough of pioneer living and moved away from the area. The abandoned property again sat vacant for several years before it was purchased by Willaford Ransom Leach, who owned the Ford car dealership in Stuart, in 1936. His wife, Anne Bates Leach, was the heiress to the Coca-Cola fortune. Leach then proceeded to build the magnificent, fourteen-thousand-square-foot, multiple-tiered structure that still sits there today. It had eight fireplaces, a huge swimming pool and a wide, sweeping balcony that overlooked the Indian River. The place became the cultural center of the area and was the site of many social gatherings, celebrations and meetings. The swimming pool was so large that the Red Cross used it to train people for proper canoe use.

In 1947, a vicious category-four hurricane made landfall in South Florida. The eye passed directly over Fort Lauderdale. Tuckahoe, with its high elevation and exposed walls, suffered severe damage. This—and a dispute with Martin County—prompted the Leaches to consider selling the property. They were concerned about the property to the south of them,

Tuckahoe Mansion full view, Jensen Beach, Florida. *Authors' collection.*

which had recently been purchased by Frances Langford, the Hollywood movie starlet. She had developed the area into small bungalow properties available for seasonal rental. The Leaches felt that their property values had been diminished and demanded that the county lower their taxes. They threatened that if this was not done they would sell the property to a nonprofit organization. When the county refused, they sold it to the Catholic Church for $75,000 and moved to a lavish Addison Mizner house in Palm Beach, many miles to the south.

The Sisters of St. Joseph then used the mansion as a novitiate, or training center, for nuns. For twenty-two years, the church used the place as a university and housing facility for nuns, adding two large dormitory wings to the building. In a strange twist of fate, the property once again became a focal point for religious activity, as it most likely had been during the thousands of years of Native American inhabitation.

## THE FLORIDA INSTITUTE OF TECHNOLOGY

In the 1960s, the organization suffered many financial and organizational challenges, and the property was sold to the Florida Institute of Technology (FIT). It then served as a campus for fourteen years. As the years passed, both FIT and Indian River Community College used the already decaying buildings on the property for classrooms when the need arose.

In the early 1980s, a professor had a scheduled class in one of the upper rooms of the mansion. On this particular night, she was administering a final exam. One of the students took an extraordinarily long time to answer the questions, so she was forced to stay late. The student finished the exam and left the building. By the time the professor gathered all of her things, she realized that the building was empty. As she left the classroom and walked down the hallway toward the stairs, she happened to turn and look behind her. She was startled to see the figure of a man standing in the shadows at the end of the hallway. He wore a long overcoat and a fedora-style hat, much like someone from the 1930s or '40s. The surprised professor called out a greeting in a friendly voice while moving quickly for the stairs. At the sound of her voice, the figure dissolved before her very eyes. She ran from the place and never returned.

## Neglect and Decay

Tuckahoe remained a campus for that organization for fourteen years, until FIT closed the branch. After the school left, the Tuckahoe mansion sat vacant on its high mound for over twenty years. The property descended into disrepair and became an eyesore with its mildew-stained walls and empty, hollow hallways. It seemed to be a remnant of days gone by, decaying in its prominent place atop the ancient Indian mound. Rumors began to circulate of strange things experienced within its walls. People interested in the paranormal ventured into the place at night in search of evidence. Many experienced cold spots in different rooms. Countless orbs were seen in the high, expansive rooms of the dark, forbidding place, and there were reports of shadow figures seen moving about, especially in the auditorium, which seemed to be the site of the most activity. There were reports of soft piano music in the still air and several accounts of a boy singing in a beautiful high-pitched voice. Visitors to the mansion have reported an otherworldly feeling as they make their way down toward the mansion's lower floors.

## Renovation and Revival

Recently, the mansion went through a $4 million restoration project that brought it back to its original grand condition. The place is now magnificent, and it is available for social functions. As the workers were digging deep into the mound for an elevator shaft, archaeologists discovered pottery shards that dated back to around 2200 BCE—over four thousand years ago.

One of the volunteers working on the project reported a very strange incident. After the rest of the archaeologists went home for the day, she was having a last look around. Suddenly, from behind the mound, a hazy figure appeared and began to move slowly toward her. It was a tall figure with the features of a Native American. Her heart froze with fear as she watched it glide slowly across the shell-covered ground. She recognized its spare attire as that of the Ais Indians, who originally built the massive shell midden. The figure seemed to gaze directly at her for a few moments and then abruptly dissolved into thin air, as if made of dust. She was so frightened that she ran from the place. Who was this lost spirit? Was it trying to send a message? Was this the only remaining tragic trace of a people who were once so great in number that they couldn't be counted?

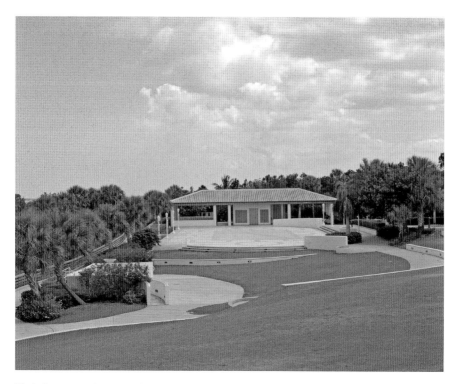

Tuckahoe grounds, Jensen Beach, Florida. *Authors' collection..*

The aspects of this are mind-boggling. For massive spans of time, people existed in this area. They lived and died there, had children, laughed and cried, worshipped, braved storms and hurricanes and stared up at the night sky at the stars with the same sense of wonder that we do. It seems very possible that their spiritual energy must remain at this sacred site. Are the spirits of the early Indians or the pioneers still present on Mount Elizabeth? You can bet on it!

# STUART

# 14

# GILBERT'S BAR HOUSE OF REFUGE

O n the south end of Hutchinson Island in beautiful Martin County, there is a very special place that has endured 140 years of change in South Florida. Perched on a craggy, windswept outcropping of Anastasia rock, the picturesque little house serves as a reminder of times past. At first glance, one might drive by it without notice, save for the lonely Daughters of the American Revolution historical marker that is visible above the white fence. Few would realize that it is known as one of the most haunted buildings on Florida's east coast.

Gilbert's Bar House of Refuge is the oldest structure in Martin County. It was there before Flagler's Florida East Coast Railway thundered through the mainland on the west side of the Intracoastal Waterway. It was there before the city of Stuart was established. It was there when wind-borne shipping was still an active business in the natural currents of the Gulf Stream only a few miles out. It is now a museum that has been painstakingly restored to its original condition. Great care has been taken to preserve it as a testament to life as it was when the coast was still wild. The House of Refuge also served as a center for sea turtle research for nearly thirty years. Marine biologist Ross Witham used the first level of the house as his laboratory, rescuing thousands of baby sea turtles and undertaking groundbreaking research. Everyone who has ever visited the House of Refuge realizes that it is a very special place indeed.

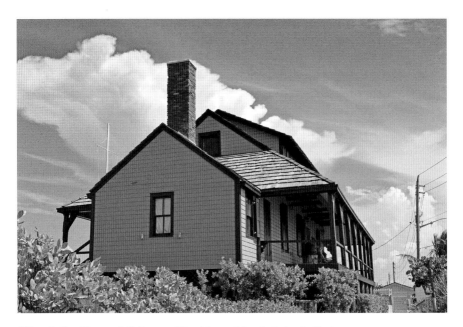

Gilbert's Bar House of Refuge on Hutchinson Island. *Authors' collection.*

## HISTORY

At the conclusion of the bloody and devastating Civil War, a newly reunited America was trying to establish its borders. In South Florida, hundreds of miles of coastline were virtually uninhabited. Through a combination of treacherous reefs, busy shipping lanes and frequent hurricanes, many a ship was wrecked on the craggy rock outcroppings that line the beaches. When one of these unfortunate maritime disasters occurred, the surviving crew and passengers were often cast out onto a desolate, hostile expanse. They would then have to endure the combined threats of the unrelenting sun with no shade, no food, no fresh water, wild black bear and panther attacks and hordes of sandflies and mosquitoes.

## AN OASIS IN THE STORM

In 1875, the U.S. Life-Saving Service was reorganized under the expert tutelage of Superintendent Sumner Kimball. Five "Houses of Refuge" were erected along Florida's treacherous coast. Ten years later, five

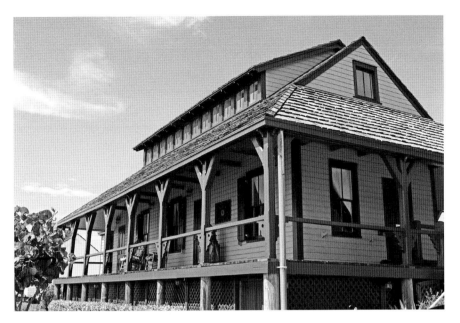

Gilbert's Bar House of Refuge from the northeast. *Authors' collection.*

more were added. The buildings were placed about forty miles apart starting in Key Biscayne, eventually extending as far north as Bulow, near present-day Daytona Beach. They were originally intended as a place where shipwreck victims could go for temporary salvation when a shipwreck occurred. The unfortunate, exhausted men would be given a change of clothes, rudimentary medical care, something to eat and a place to recover for up to two weeks before being moved north by boat or, after 1895, by railroad. The houses were staffed by a keeper, usually accompanied by his wife and family, whose job it was to patrol the beaches after a storm in search of hapless victims of Mother Nature. This was a time before the enormous development of South Florida. Such luxuries as air conditioning and electricity were not yet available, so it was a hard life. There were often long stretches of monotonous inactivity lasting months, sometimes even years.

# THE AIS

## *Former Occupants*

Gilbert's Bar House of Refuge is the only one left. All of the others are gone, so it is a historical treasure. When choices were originally made for the proper location of the houses, sites were chosen that were ideal for safe and successful settlement. Many of these sites, including the one at Gilbert's Bar, had already been chosen by earlier inhabitants. In 2004, Hurricanes Francis and Jeanne washed away many of the sand dunes surrounding the house of refuge and scoured out the craggy rocks on which the house sits. Evidence that vigorous habitation had occurred up and down the beach was exposed. This occupation occurred earlier and longer than anyone knew. It was determined that the House of Refuge sits on a village site of the Ais Indians. These Native Americans occupied the property as long ago as the year 800 BCE. Ancient burial grounds were discovered both north and south of the house on Hutchinson Island. Ancient skeletal remains that had been bundled and once buried were discovered in the crevices of the exposed rocks and were subsequently excavated and re-interred at a remote location. The site was then blessed by a Seminole shaman.

The Ais were a deeply spiritual people who had strong beliefs about the afterlife, and their seemingly bizarre rituals were documented in a well-known journal kept by an English Quaker and shipwreck survivor named Jonathan Dickinson. In 1696, Dickinson's ship, the *Reformation*, was damaged and ran aground during a storm. The ship's occupants survived the disaster but were stranded on present-day Jupiter Island. Dickinson and his crew were taken prisoner by a southern sub-tribe of the Ais known as the Jeaga. He referred to these fierce people as "the furies." Fortunately, the Jeaga warriors did not kill them immediately, choosing instead to take them as captives. His journal, titled *God's Protecting Providence*, is one of the best accounts of what the eastern Florida coast was like before European development. It is also one of the greatest survival stories in the history of Florida.

The energy of this once vibrant and violent people still remains on the lonely beaches. Are they angry that the house was built so close to the resting place of their sacred dead? Do their vengeful spirits want retribution for the loss of all of their people? Many have seen strange lights near the house—especially on nights with a full moon—and heard the lonely sounds of wailing voices, barely audible over the crashing surf.

# DON PEDRO GIBERT

Right up until the 1830s, the waters around where the House of Refuge would later stand were often inhabited by pirates. Because of Hutchinson Island's proximity to the busy Gulf Stream and its convenient inlets to the Indian River, it was an ideal place for criminals and buccaneers to hide from authorities. Some of the earliest pioneers of the island complained to authorities of pirates raiding their crops for food. The legend of one such man still shines as a testament to this period of time.

Don Pedro Gibert, a sailing captain of Colombian descent, had decided to turn to the life of a sea criminal. It is said that he loved the area because the natural hills, called "Bleech Yards" on early nautical maps, made it easy for him to conceal his pirate vessel, the *Panda*, from anyone who happened to be looking for him. The legend states that Captain Gibert's technique was to spot any vessel within sight of shore from his lookout point on a natural formation called Mount Pisgah in modern-day Jensen Beach and then sail out through the inlet to attack it. Once this had been accomplished, he would beat the crew members until they told him where the cash box was. When this was done, he would lock the crew of the ship in the hold, set the ship on fire and sail away. His motto was "Dead cats don't mew; you know what to do." No witnesses were to be left alive.

Unlike other pirates, Don Pedro was famous for not hoarding his captured loot for safekeeping, instead choosing to squander it at the nearest port of civilization on wine, women and song. In the early 1830s, Gibert and his men audaciously attacked a ship called the *Mexican*, stealing over $20,000 in specie from its hold. The search for justice was now on. Gibert and his men were apprehended near the coast of Africa, where the *Panda* was destroyed. The prisoners were then transported to Boston, Massachusetts, where there was a huge trial. This was in the days before sporting events or the Internet, so people would go to trials, especially *pirate* trials. Over twenty thousand people attended the spectacle. Hangings were very popular events, and Gibert's did not disappoint. He and his men were sent to the gallows for the crime of piracy at the Leverett Street Jail in 1835. They were among the last men executed for this crime in the United States.

## THE LEGEND LIVES ON

Even though Gibert is gone, his name stuck and the legend remains. The land on which the House of Refuge stands is called "Gilbert's Bar" to this day, the *L* being added to his name sometime over the years. Many believe that Don Pedro Gibert never left the place that he loved so much. It is possible that Gibert's murderous spirit is so malevolent that it continues to cruise the place that took his name. People have reported seeing a black vessel drifting in the river on the darkest of nights, its gun ports glowing red like a demon's eyes. Is this the *Panda* searching for one last victim?

## THE WRECK OF THE *GEORGES VALENTINE*

On an October night in 1904, a terrible gale wracked the sea near the House of Refuge. A ship named the *Georges Valentine* had run aground on the reef and was in grave danger. It was a steam-driven supply ship that had been recently converted back to wind power and was unable to fight the hellacious winds of the storm. Men clung to anything they could as the sea pounded their vessel and drove it perilously close to the dangerous reefs near the shoreline. Soon the inevitable happened, and the ship was tossed onto the rocks, completely destroying the vessel and reducing it to flotsam. Men were cast into the sea to thrash about and struggle for their lives as they tried to steer clear of tons of loose wooden boards that had broken free and were slamming together with the stupendously high waves, crushing anything that drifted between them. One man made it to the rocks and dragged himself to the porch of the house. He then banged on the door, notifying the keeper of what had happened on his very doorstep. Five men lost their lives in the terrible seas directly in front of the house that night.

Gilbert's Bar House of Refuge historical marker. *Authors' collection.*

There was another shipwreck the very next day. A Spanish

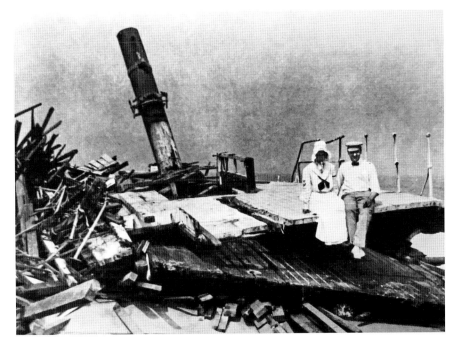

*Georges Valentine* wreck at Gilbert's Bar House of Refuge, October 1904. *State Archives of Florida, Florida Memory.*

vessel, the *Cosme Calzado*, wrecked a few miles north of the house in the same storm. There were twenty-two miserable, bedraggled shipwreck survivors in the house that stormy evening, making it the busiest night of the House of Refuge's existence. There were so many men that Mrs. Rea, the keeper's wife, had to cook the soup in the largest container she had available: her laundry tub.

# WORLD WAR II

## *Constant Vigilance*

In 1915, the U.S. Life-Saving Service merged with the U.S. Revenue Cutter Service, and the U.S. Coast Guard was born. During World War II, the House of Refuge was an important asset to the military. The tall observation tower that still stands there was used as a submarine and airplane spotting station. The tower that stands on the property was constantly manned by

Gilbert's Bar House of Refuge from the river side. On the left is the observation tower used to spot planes and submarines during World War II. *Authors' collection.*

coast guard personnel to watch for attacks by an unseen enemy. German U-boats were a constant, lurking danger to merchant vessels. Sailors patrolled the many miles of desolate beach on horseback. Residents had to black out their windows at night. The newly formed U.S. Navy Frogmen and Underwater Demolition Team trained on the beach a short distance to the north, and Camp Murphy, later known as Jonathan Dickinson State Park, was a top-secret radar training facility a few miles to the south. There were many freighters and military vessels that were torpedoed a very short distance from the shoreline—many more than were ever made public. There were twenty-four vessels torpedoed by the Germans on Florida's coasts, a high percentage of them near Martin and Palm Beach Counties. The military, wanting to avoid panic, did not want the general public to know just how close the war was to their front steps. How many lonely, brave sailors of all nationalities lost their lives in the rough surf during those years? Are their heroic, lost spirits still wandering the beachheads?

## SPIRITS THAT REMAIN

After World War II, the House of Refuge was decommissioned by the federal government. It then sat empty for eight long years. It was during this time that a veteran sailor named William "Captain" Louis Bartling's boat ran aground on the north end of the property. He ended up staying there for many years, squatting. The coast guard knew that he was there but apparently did not see him as a threat, as they did not run him off. Many people in Stuart knew him and liked his boisterous, friendly personality and masterful storytelling ability. It was said that he enjoyed his drink quite a lot. Friends would visit

him, bringing gifts of food or giving him a ride if he needed it. He was so well liked that when Martin County wanted to purchase the property from the federal government, there was a stipulation that "Captain Louie" be taken care of in his old age. His welfare was part of the deal. On a dark night in 1958, the Indian River Bridge tender reported that he could see the brilliant red flames of a fire on the south end of Hutchinson Island. By the time help arrived at the site, the small shack that Captain Louie had constructed next to his boat was completely engulfed. The fire raged wildly and could be seen for miles through the darkness. When the firefighters finally got control of the inferno, they found Captain Louie's remains in the cinders. Tragically, he had lost his life near the place he loved so much. Many people feel that he is still there. He is perceived as a playful spirit, knocking on walls, giggling softly in people's ears or tugging on their shirttails when they are not looking. He means no harm and welcomes all guests to the house.

During the turbulent history of the House of Refuge, many tragic events occurred. Unlike today, medicine was not readily available, so people would suddenly get sick and often die. The weather would often turn abruptly and unleash its wrath on the house's inhabitants. To this day, many have gotten the strange sensation that some sorrowful entity wanders the hallways of the house, searching for a lost lover. A few people have shared seeing a small girl dressed in clothes from the late nineteenth century in the parlor area.

There have been multiple sightings of a woman's face in the upstairs loft window. According to witnesses, she gazes longingly out to sea, as if watching for shipwrecks in the distance. It is believed that this may be the spirit of Susan Bessey. She was the wife of Hubert Bessey, who served as keeper of the house from 1890 to 1902. Susan did her very best to make life at the house agreeable for her husband and everyone who came there. Her husband was a very talented boat builder and kept busy most of the time in a workshop on the north side of the house. Susan kept a clean and orderly house and loved to entertain guests whenever she could. She spent many years at the House of Refuge, and some feel that she may have returned to the fine tablecloth and buttercup china that she cared about so much. There have been reports of the fragrance of a delicious stew cooking in the long-unused kitchen of the house. Is Susan Bessey still cooking for the spirits of destitute seamen from the past?

On dark, stormy nights, many have seen hazy white figures floating slowly along the beach near the *Georges Valentine* wreck site. It is believed that these are the souls of the men who perished, wandering the beach like displaced

Gilbert's Bar House of Refuge as a storm rolls in. *Photo by Linda Geary.*

vagrants from another world, still wondering what happened to them, snatched from life so abruptly that they have not yet realized their fates.

During tours, people hear strange knocking sounds from the attic. The guides tell them that it is the relentless sea wind playing against the ancient joints of the place, but a few of us know better. It is our personal belief that the spirits of Gilbert's Bar House of Refuge will never leave the place they love. Still today, on moonless nights, beachgoers see strange, unexplainable lights near the house. Do the energy and spirits of the once vibrant and violent Ais people continue to roam the beaches of Hutchinson Island? Are they angry that the House of Refuge was built so close to their sacred burial grounds? Do their spirits want retribution and revenge for the loss of countless loved ones? Is it the wailing voices of these wandering souls, barely audible over the crashing surf, that can be heard as the lone sea turtle struggles ashore during the full moon to deposit her precious clutch of eggs?

# THE ASHLEY GANG

## SOUTH FLORIDA'S BONNIE AND CLYDE

In the early 1920s, Martin County did not yet exist. Salerno and Stuart were still part of the northernmost section of Palm Beach County, and much of the area was still rural, untamed and mostly overgrown with palmetto scrub and thickets. The resourceful people who lived there were as tough as their environment and did what they had to do to survive. Joe Ashley and his family resided in the area known as Gomez, a short distance south of the fishing village of Salerno. Years earlier, he had moved his family there from Pompano Beach to work as a sheriff's deputy in Palm Beach County and ended up settling in. He soon grew weary of the job and chose a more lucrative career: bootlegging.

The Ashleys were a rough, tightknit family who were well known for their generosity in the fishing community of Salerno. One of Joe's boys, John, would grow to become one of the most infamous people in Florida history. During the Roaring Twenties, the Ashley Gang, as they were known all over the state, set the stage for later renowned outlaws like Bonnie and Clyde, Pretty Boy Floyd and John Dillinger. Accused of robbing over forty banks and claiming over $1 million in booty, they were hunted by law enforcement for years. Throughout their reign of terror, they called Salerno and tiny Gomez their home.

Growing up, John was considered a bright and resourceful boy and a natural leader. Like many other youths in the area, he had spent most of his young life in the Florida Everglades, where he became an accomplished woodsman and trapper at an early age. He began his criminal career with

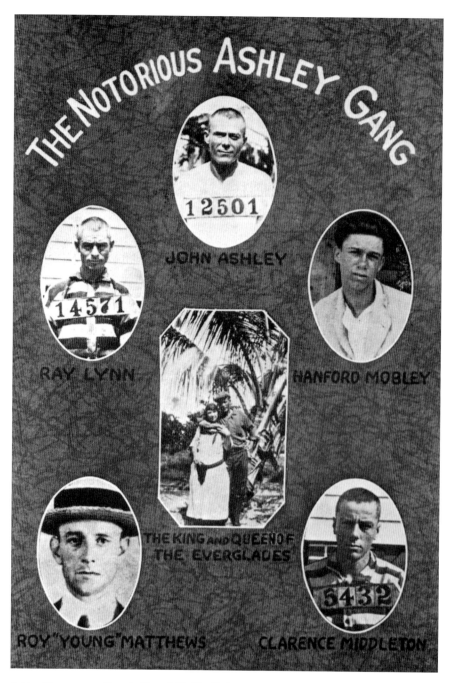

Ashley Gang poster. *State Archives of Florida, Florida Memory.*

John Ashley and his sister, Eva, at Gomez. *Steve Carr collection.*

a strange incident that occurred when he and a Seminole Indian named DeSoto Tiger went on a hunting trip in the Everglades. Sometime during the solitary isolation of the trip, there was some sort of disagreement between the two men. It is generally believed that alcohol was involved. Whatever happened, only John returned. He told no one what had occurred on the trip but wasted no time in cashing in the hides he and DeSoto had collected. A short time later, DeSoto Tiger's decomposing body was found by dredge workers, and John Ashley found himself accused of murder. His reluctance to cooperate in the investigation angered both law enforcement and the Seminole tribe. When Sheriff George Baker sent two deputies to the small settlement of Gomez—where the family homestead was—to make the arrest, John and his brother Bob ambushed them. They chose not to hurt the terrified deputies, instead sending them back to the village of Stuart with a message for Sheriff Baker not to "send any more chicken-hearted men, or they might get hurt." This enraged the sheriff and started a personal war between the Bakers and Ashleys that would last for years. At that time, and in that rural community, there was a thin line between the "good guys" and the bad, and rules were often bent on both sides.

## CRIME AND POWER

John was not your average criminal. He made a mockery of law enforcement by successfully escaping from prison three times during his wild career. After he and his gang brashly robbed the Stuart bank, one of his gang members, "Kid" Lowe, accidentally discharged his weapon, shooting John in the jaw. This cost the outlaw the vision in his left eye. In later photos, John is seen wearing an eye patch. He later replaced the patch with a glass eye, an item that his nemesis, Bob Baker, the son of Sheriff George Baker, swore that he would wear one day as a watch fob. When John was later arrested and incarcerated in the small city of Miami, his brother Bob went on a daring suicide mission to get him out. Bob Ashley's brazen, foolish actions caused a reckless street shootout that resulted in two deaths, including his own. The citizens of Miami were so scared of the Ashley Gang that the sheriff had to parade Bob's corpse through the streets to prove that he was dead and law enforcement still had the upper hand. Unfortunately for Bob, John Ashley was found not guilty of the murder, but he was sent to Raiford State Prison for the Stuart bank robbery.

## FEAR AND NOTORIETY

The Ashley Gang was so successful that it eventually became South Florida's scapegoat, often being falsely accused of robbing banks all over Florida. Almost every major crime in Florida was blamed on Ashley and his men. One Florida official called John the greatest threat to the state since the Seminole Indian Wars of the 1830s. The newspapers of the era frequently compared him to Jesse James. He seemed to relish the image of the swaggering, brash outlaw who did things his way, often spitting in the eye of local law enforcement. Among the poor Florida "crackers" of the area, John was considered a folk hero who represented a southern symbol of resistance to bankers, lawmen and wealthy landowners. He was generous to people he considered his friends and refused to steal money that was destined for residents of his own community. He often used the intervention of the hated "Yankees from up north" as an excuse for why he had been "forced" to live a life of crime. According to him, the Yankees owned all of the insurance companies, so robbing banks and selling illegal whiskey was the only way to get the money back into southern hands.

John's lifetime love was Laura Upthegrove. A member of one of the oldest families in the area, Laura grew up in the rural community of Okeechobee. She was described by a reporter in the book *Florida's Ashley Gang* by Ada Coats Williams as "a large woman with dark hair, a deep suntan, and a .38 caliber revolver strapped to her waist." Laura participated in everything the gang did. As time passed, people began to identify her as the "Queen of the Everglades." Her torrid relationship with John meant that she was very influential in the activities of the gang. She was not afraid of anything and loved the exciting life of an outlaw.

## PROHIBITION

In 1919, the Eighteenth Amendment to the Constitution was ratified, prohibiting the manufacture and sale of alcohol in the United States. One year later, the Volstead Act was approved, and it clarified the intent of the bill. This had a profound effect on the economy on Florida's southeast coast, especially on the smaller, more remote communities like Salerno. In the 1920s, South Florida was in an economic stranglehold, with most people living day to day, often barely above starvation. Bootleg whiskey production quickly filled the void, becoming the only going concern in the area other than commercial fishing. Numerous fishermen in the area became part-time bootleggers and grew proficient at making their own whiskey. At that time, the area was still relatively wild and untamed. Today, the area around Salerno is dotted with old still sites. During those riotous years, there was no problem at all obtaining illegal booze. There were a few loopholes in the law, the main one being that it did not make the actual *consumption* of alcohol illegal. A famous saying of the day was "anywhere but the bank." You could purchase booze at almost any filling station. Many people had false bottoms in the trunks of their cars for bottle storage. Law enforcement was always on the lookout for suspicious activity, but many officers were also involved in the trade and often turned a blind eye.

With the advent of Prohibition, the Ashley Gang seized on the opportunity almost immediately, as did many other members of the local Salerno community. Julius W. "Joe" and his five sons soon controlled the whiskey business in the area, proving to be the most prolific moonshiners and rumrunners in South Florida. Fort Pierce, to the north, was already a well-known port community, as was West Palm Beach many miles to the

south. In between them was dark little Stuart and, even smaller yet, the village of Salerno with its convenient little Manatee Pocket. This proved to be the perfect place to smuggle illegal contraband in and out under the cover of night. Prohibition was not in effect in England, so there were British-owned alcohol warehouses in West End in the Bahamas and Bimini to the south, nearly a straight shot trip of sixty to eighty miles from the Stuart Inlet. Rumrunners would leave the Port of Palm Beach, where they went through U.S. Customs, before heading straight to the Bahamas to load up. Then they would bring their cargo into the Stuart Inlet and into the Manatee Pocket to offload to local illicit distributors. John Ashley's illegal exploits were not limited to bootlegging and bank robbery. He was the last legally declared "pirate" to attack and successfully rob the liquor warehouse in West End.

## SHOOTOUT IN GOMEZ

Little Gomez was not only home to the Ashley Gang, it was also the location of the largest of the gang's three moonshine operations. The Ashleys' illegal enterprise employed countless local men and women—boosting the economy and saving locals from extreme poverty—as woodchoppers, mash-makers, boilers, bottlers, delivery drivers and even mule-team drivers. Local women were paid well to bring meals to the workers and wash and mend their clothes. Joe Ashley's above-standard wages earned him loyalty and protection from everyone involved. The family was not without its enemies, though, most notably John's old nemesis, Palm Beach County's notoriously corrupt sheriff, Robert "Bob" C. Baker. Baker and his henchmen conveniently overlooked the illegal business in the county as long as his ever-increasing demands for "hush" money were promptly met. Bob Baker had a deep hatred for John Ashley because of the humiliation the gang put him and his officers through—and because of a woman. The woman was none other than John's future soul mate, Laura Upthegrove. Before she ever met the brash outlaw, Laura met Bob Baker when he was still a jailer at the prison. Due to her wild ways, she was often incarcerated, and it is widely believed that she used sex as a way to win over her captor, thus shortening her sentences. Baker, who was already married, fell for her hard, traveling out to her home in Okeechobee whenever he could to see her. When Laura met young, handsome John Ashley, she dumped

him, thus starting a war that would go on for years, worsening when Bob Baker became sheriff after his father died in 1920.

John and Laura were then driven into a life of crime by the relentless pursuit of the jilted sheriff. They began robbing banks and trains in Baker's jurisdiction, thus embarrassing him and flushing out his true evil intentions. In January 1924, Baker extorted information from one of Joe Ashley's still workers. When he learned that John and Laura were hiding out at the still in Gomez, he organized a posse of fifty riders on horseback to raid the place under the cover of darkness with the intention of killing them both on the spot.

John Ashley and Laura Upthegrove. *Steve Carr Collection.*

## ALBERT MILLER

Albert Miller was a very close friend of Joe Ashley. He worked at the Gomez whiskey operation and was also proprietor of the small general store in town. He was with Joe on a fateful January night, sitting in a tent at the still site, playing a quiet game of chess by low lantern light. Suddenly, the camp dogs began to bark a warning, and the two men sprang up from their chairs. They could now hear riders approaching through the woods at a fast pace. Joe Ashley picked up the lantern from the table and turned the dial to make it brighter. He then pushed the tent flap aside and stepped out into the dark night. The sound of gunfire erupted, and Joe was instantly hit with a hail of bullets. He fell into the tent backward, dead before his body landed on his cot. Albert was also hit twice. He was shot in the hip and grievously wounded in his right arm.

In the tent across the way, John Ashley, enraged by the surprise attack, snatched up his old rifle and ran out into the night, still in his underwear. He made his way to a thick, forked tree for cover and quickly aimed his

weapon toward the approaching maelstrom of horses. Frantically searching for a target, he saw some palmetto leaves move a short distance away. He took aim and shot. He heard a man scream, so he turned and ran back into the tent to get Laura. Both of them were nicked by several bullets but not injured seriously. They met up with a severely wounded Albert a short distance away in the woods, where they had earlier concealed a camouflaged vehicle for escape purposes. They scrambled into it and peeled off through the trees, successfully making their getaway. In the days after the shootout, Albert learned that Fred Baker, the sheriff's cousin, was killed in the raid. It was never proven that John was the one who shot him that fateful night because several other deputies were injured as well.

## The Gang Meets Its End

John Ashley's bitter, violent, thirteen-year feud with Palm Beach County sheriff George B. Baker ended in a brutal confrontation on a moonlit Halloween night in October 1924 at the Sebastian Bridge, fifty miles north of Stuart and Port Salerno. Getting a tip that the gang was headed north, Baker and his deputies devised a plan. Highway A1A was the only road that the outlaws could use to escape, so the deputies hung a heavy chain across the south side of the road leading over the bridge. They suspended a red lantern on the center of it and hid their police cars in the mangroves. John and three other gang members soon arrived at the roadblock. The circumstances of what happened next are very murky. The deputies reported that the gang members were shot while trying to escape. Later released eyewitness accounts tell a different story. According to them, the men were ordered out of the car and handcuffed, and John was separated from them. A few words were exchanged, and John took one step forward. He was instantly shot dead. The other handcuffed gang members panicked and tried to bolt and were also shot. The verdict by the coroner's jury was "justifiable homicide." Many locals believe that it was cold-blooded murder. Their emaciated bodies were later displayed on the street in front of Fee's Mortuary in Fort Pierce for all to see, like grisly hunting trophies.

The Ashley Gang was such a strong force in the area of Stuart and Salerno that its energy still remains. Remnants of their still sites can be found in remote corners of the area. Having been robbed of life so violently and abruptly, many believe that John and his lieutenants still roam the places

John Ashley's grave in the Ashley family cemetery, Port Salerno, Florida. *Authors' collection.*

they frequented in life in search of vengeance for what they believe is their cold-blooded murder.

Over the years, there have been many legends that have become well known about the Ashley Gang. In the next few pages, we will share the most popular ones with you.

## JOHN ASHLEY'S DREAM

John Ashley was back in jail. He had been caught transporting a load of illegal booze in the town of Wauchula. One night, John went to bed in his cell as he always did, even though he had a bad feeling about something. Back in Salerno, two of his brothers were leaving the dark Manatee Pocket in an empty boat, headed toward West End in the Bahamas to make a liquor deal. Ed and Frank Ashley had done their best to continue the crime operation in their brother's absence and supplemented their operation by hijacking other bootleggers on the water. Needless to say, they were not popular with the other smugglers in the area. They reportedly made it to the Bahamas but were delayed by bad weather. Despite warnings, they left the warehouse with over $13,000 worth of illegal booze on board their overloaded little craft. That was the last time anyone ever saw either of them alive. As John slept, a terrible, vivid dream came to him. He saw his two brothers in their small, overloaded boat, pitching and heaving with the high waves of a storm. He then saw the hulking shape of a larger vessel approaching them through the driving rain. Incredibly, he knew who the three men were on board. Jim White, Bo Stokes and Alton Davis were rival bootleggers and pirates, and John knew what they were going to do. The next morning, he woke up covered in sweat and agitated. Later, the news came that John's two brothers had vanished without a trace. John Ashley instantly knew what had happened. He swore that he would take his vengeance on the three men when he was released. His jailers laughed and disregarded his "vision." A few months later, White, Stokes and Davis disappeared without a trace. Were these men "lost at sea" like Ed and Frank, or did the Ashley Gang have the last laugh?

## GHOST BOAT

How did John know what had happened to his siblings? Did he have a paranormal experience or premonition? No one knows for sure. A few days later, a mysterious boat washed ashore in nearby Jensen Beach. There was not a soul on board, and no one claimed ownership. The vessel was badly damaged and appeared to have been hastily lashed together, as if split by a vicious storm. The bottom of the boat was full of broken bottles, and it reeked of alcohol. People got a strange, unexplained sense of tragedy

that seemed to emanate from the wreck, and most stayed clear of it. A few believed that this was Ed and Frank's doomed vessel. Had they met their end in the clutches of a brutal nor'easter? The gang's activities also hindered Prohibition-era bootleggers in larger cities like West Palm Beach and Miami, whose importation of foreign liquor undermined local moonshiners. Had they run into some angry mobsters or rumrunning rivals who had dished out their own form of justice? No one will ever know. For years afterward, many boaters reported seeing the shadows of a boat matching the one the brothers used speeding toward the inlet with no running lights. Could Ed and Frank still be trying to cash in one last time?

## THE LEGEND OF JOHN AND THE DRIFTER

About thirty miles south of Salerno, a drifter walked the rails north, looking for work. He was like so many others—lost in time, adrift in the wash of desperate poverty that was so prevalent in South Florida at that time. It was blazing hot, and his clothes were ragged and dusty. The sweat poured from his face under the slouch hat he wore. In a place called Riviera Beach, he stopped by a local speak-easy and asked where he could find work. He was advised to walk up the railroad tracks to a place called Gomez and find a man named Ashley. He had heard the name somewhere before but couldn't remember where.

He walked for two full days in the blazing sun, waiting to see a sign marked "Salerno." At a bend in the railroad tracks, he saw a two-story clapboard house. He walked up the wooden steps onto the porch and knocked on the screen door. No one answered, so he knocked again, this time more loudly. There was a stir of movement inside, and he heard someone lifting the latch from the inside. She was an older woman with a thin figure and an attractive, open face. Her apron was dusted with flour, as if she had been baking. Her hair was graying at the temples, but her blue eyes were piercing with intelligence. The drifter asked about work. The woman told him that her sons were out working and wouldn't be home for a few hours. Over her shoulder, the drifter saw another face. It was a young girl. She was pretty in a way, but there was something amiss in her eyes, and her face was dirty with food. He immediately surmised that she was mentally slow.

The drifter asked if it would be all right if he waited on the porch. The woman agreed and offered him something to eat. He thanked her, and the

woman went back inside. The drifter then decided to do something very bad. He rose from his chair and walked to the door, opening it and slipping into the cool darkness of the house. For the next two hours, he sexually violated both of the women. When he was through, he left the house with a stolen bottle of whiskey and commenced walking up the tracks to the north.

A few hours later, John Ashley; his father, Joe; and his brothers got home from working the nearby stills. John grew stoic as he listened to his mother recount what had happened to her and his sister. He said nothing and disappeared through the door. He soon found the drifter at a speak-easy in Salerno. John stood behind him, saying nothing, until the drifter became aware of a presence near him. He looked up to see a lone man gazing at him, dressed in dirty blue jeans and a western-style white shirt, with a straw hat cocked at an angle on his head. John politely introduced himself and calmly explained that he knew what the drifter had done. He then placed his two revolvers on the bar. The drifter recognized the name now from countless news reports and suddenly realized the gravity of the mistake he had made. The fishermen in the bar knew that trouble was coming but did not leave because they knew what a good shot John Ashley was. It was said that he could shoot the top of a soda bottle as it rolled across the floor.

John told the drifter that he was going to count to three. The man protested weakly, and John started to count. When he reached three, his hands were a blur as he snatched up both weapons and fired first one, then the other. The drifter was dead before he hit the floor, a look of shocked pain and surprise on his face. Now, John and the fishermen had a problem. There was a dead man on the floor of the illegal speak-easy. Together, they came up with an idea. Darkness had fallen, so they carried the drifter's body down to the fish house by the docks. They then put the body into a great gnashing machine called a fish chummer. There was never an arrest made, nor was the drifter ever identified. He became one of the countless lost spirits that now haunt the docks of Salerno.

## ALBERT MILLER'S GHOST STORY

John and two of the men murdered with him were buried next to Joe Ashley in the family burial plot in Gomez. On Sheriff Baker's orders, Joe Ashley's fine house was burned to the ground, followed by Albert Miller's general store. Miller hid out for several years until Sheriff Baker's untimely death

due to a heart attack. Albert lived a long and relatively obscure life after his brush with the outlaw life, lasting well into his nineties. In 1983, he was tracked down by author Ada Coates Williams, who found him working in a hardware store in Stuart, Florida, at the ripe old age of ninety-four. Williams was writing a book about the Ashley Gang, *Florida's Ashley Gang*, released in 1996, and wanted to interview him for her well-researched work. In March 1998, author and historian Stephen M. Carr spent three hours with Ada Coates Williams. They had a long discussion about the Ashley story, during which she shared Albert Miller's story.

*In nineteen twenty-five or twenty-six I had sentimental feelings for my dear old friend Joe Ashley. I had not visited his grave for fear of a trap by Sheriff Baker's men, who would kill me on sight. Late one evening I decided on a visit, thinking that even Baker's men would not be as watchful late at night. As I walked through the woods toward the Ashley family cemetery at Gomez, I began to distinguish an unusual form of light radiating high over the trees from a point near or at the graveyard. Since there were no homes or businesses for several miles around, I could not imagine from what source the light could come from. Thinking now that Baker's men were there and watching for me, I decided to hold fast and listen. The sounds I heard were not from the Sheriff's deputies, but rather quite strangely, they were the same noises I would hear nearly every day back at the whiskey camp. Surplus steam being let off, men laughing and whistling, the ringing of an axe chopping wood, even the model "T" engine that ran the mash scrambler. It was all unmistakable to me, so I began walking rather briskly toward the light. At first the sounds grew louder and the light brighter. I was sure that I could even hear old Joe's voice hollering for buckets of water from the pump.*

*As I got closer, the light began to dim and the sounds faded. When I entered the graveyard clearing, there was not a soul inside. The only light was from the moon and stars. At that point I was considering myself to be mad, but before me stood the memorial stone of my dear friend, and my mind transcended from the unbelievable back to stark reality. Joe was indeed as dead as when I last saw him, and all of my sorrow and tears could not change that.*

*I would never visit that grave again, but for many years I have tried to make sense of what I experienced the night of my one and only visit. In the shadows of my own mortality, I have accepted the gift that was given by the spirit of my dead friend, that being a cherished few moments to re-live the happy but fleeting memories of our days together in the whiskey*

*camp. I believe now and forever that my departed friend sensed my approach to his final resting place and summoned up an unnatural miracle of sight and sound as a tribute to our kinship.*

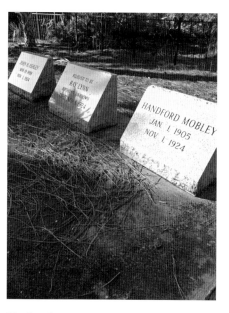

When Steve Carr recorded the details of Albert Miller's interview with Ada Coates Williams, she shared her own story regarding the interviews she did with several of the residents of the Mariner Sands development of new homes that now surrounds the Ashley family graveyard. It seems that there was a common narrative from many of the residents whose homes are located closest to the cemetery. Many of them, on random nights, would experience unexplained noises and unusual lights emanating from the Ashley cemetery. Nighttime security guards employed by the community responded to numerous complaints of unexplained activity but always found the graveyard deserted, unlit and quiet. Nevertheless, the complaints continued night after night, eventually forcing the community board to install a fortress of hedges and trees to satisfy the residents. Could it be that the spirit of Joe Ashley wanted the family graves to be concealed and protected from outsiders?

The headstones of John Ashley, Ray Lynn and Handford Mobley. *Authors' collection.*

## HEROES OR VILLAINS?

There is a legend that the old-timers tell about the bridge on which the Ashleys spent their last minutes on the cold Halloween night in 1924. According to them, something very strange used to happen on the anniversary of the shootings. In the early morning hours of the first day of November, people would find four puddles of blood in the very spots where the outlaws were shot. No one saw anything during the night, but

the puddles would always be there. According to locals, this continued for many years after the shootings. Was this a paranormal occurrence or a ritual perpetrated by someone to remember the bloody truth of what happened that night?

John Ashley and his gang were seen by many as Robin Hood–like heroes to the rural, hardworking people of South Florida in the Roaring Twenties. At that time, the place was like the Wild West, with law enforcement often as corrupt as the supposed criminals. The Ashleys were indeed lawbreakers, but they also helped the community to survive in very tough times. They should be remembered not as vicious killers and outlaws but as people like us who were basically good at heart but happened to make a few decisions that placed them on the wrong side of the law. John Ashley is truly a tragic character in that he strove for fame and notoriety but ended up paying the ultimate price when he did achieve it. The story of the "notorious" Ashley Gang is an American story and should be remembered as an important part of the rich heritage of the haunted Treasure Coast.

# PORT SALERNO

# 16

# FOREVER TIED TO THE SEA

A few miles south of Stuart, Florida, lies the small hamlet of Port Salerno. It rests on the bank of a shallow extension of the Stuart Inlet called the Manatee Pocket. If you stop for a visit, you may get a sense of the history of the place as you amble along the fishing docks between the many bars and restaurants that now populate the waterfront. Try to imagine it without any of the bright signs, half-inebriated revelers and hordes of automobiles that fill any space large enough to accommodate them. Picture a waterfront completely lined with commercial fishing boats of all sizes and the dank, thick smell of fish filling your nostrils. You can almost hear the rumble of countless boat motors and the hard-edged voices of the swarthy, foul-mouthed fishermen as they toil to bring in the day's catch. Picture the dock railings lined with hundreds of nets strung out along them, drying in the night air.

Outsiders had to be careful when they ventured into one of the few drinking establishments there because they often became the night's activity. Fighting was a pastime for many of the rough-and-tumble, hard-drinking fishermen. If there was no one else to fight, they would brawl with one another. Bloodied and bruised, they would end up laughing and sharing a beer. Back in those days, the fishermen were clannish in nature and protected one another tenaciously. Salerno has always been a tightknit fishing community, with many families dating back three or even four generations. For that reason, the place seems to naturally conceal and, in some cases, completely hide its murky secrets. Port Salerno is very haunted, and paranormal activity is everywhere. Sailors and fishermen are the most superstitious people in history, so it's easy

to see why there are many spirits of those lost that cling to the place. The authors have owned and operated Port Salerno Ghost Tours for many years and have documented many of the spirits that are mentioned in this chapter.

Salerno has always been about fishing. If you visited the area in the early 1890s, you would have seen a different place. There would already be several hardscrabble fishermen working there, surviving on their daily haul. The Manatee Pocket was surrounded by thick, overhanging mangroves that would almost completely hide the shoreline from view. Not many development-minded businesspeople had yet come to the remote place because the environment was very harsh. Much of the land had not yet been dredged and was still swampy and inundated with water. Air conditioning had not yet been invented, and mosquitoes and the voracious no-see-ums would have been maddening to the average Yankee visitor.

South Florida was part of the Deep South, and the echoes of the great Civil War still ruled the day. Most pioneers chose to live there because of inexpensive land, solitude and freedom to live the way they wanted. The original pioneers were some of the toughest, most resourceful people in the world and tenaciously clung to their way of life. After all, despite the insects, harsh conditions and wild animals, the place was beautiful even then, especially in the winter months. When the railroad came through in 1895, the settlement became a "flag stop"—a place where the train only stops when signaled for. In the late nineteenth century, the place was so small it didn't even have a name. The story of Salerno's original name is quite interesting and may explain why it seems to be so susceptible to paranormal activity.

## The Village's First Name

Henry Morrison Flagler, the father of the Florida East Coast Railway, was a very busy man. He was on the road constantly with a full schedule of meetings and impending business ventures. In his earlier years, Flagler had become wildly successful with his business partner John D. Rockefeller in a company named Standard Oil. His wife, Mary Harkness, had a weak constitution and was sick most of the time. She suffered from what was known then as "consumption," better known today as tuberculosis. Henry brought her to Jacksonville with the hope that the warmer climate would help her condition. This move did not have the desired effect, so Flagler

hired a live-in nurse to provide constant care for Mary. The woman he hired was Ida Alice Shourds, the daughter of an Irish Episcopal minister.

Mary Harkness eventually succumbed to the disease, and Henry was left alone with a son to raise. He had gotten to know Alice quite well over the time she had spent in the house, so two years later, he married her. Ida Alice Shourds became Mrs. Henry Flagler in 1883. Due to her upbringing in extreme poverty, Alice was never accepted by Henry's New York society acquaintances. It was for this reason that she loved St. Augustine. She and Henry spent a great deal of time there, and it is said that her influence on the city was never fully appreciated. She still had a hard time adjusting to Henry's long absences and his lavish, but lonely, lifestyle. The stress of it took its toll on her personality.

Alice's behavior started to grow more erratic. She was prone to fits of anger and would go on spending sprees to rebel against Henry's pleas for restraint. She made a scene on the family yacht in New York by stubbornly refusing to allow the captain to return to port in the face of approaching foul weather. The vessel barely made it back intact. One of her acquaintances gave her a Ouija board, and she soon claimed to be having long conversations with the dead through its use. She claimed to have communication with a long-dead czar of Russia, whom she believed was her true husband. Henry was horrified by this behavior and began to seek medical help for Alice, whom he truly loved.

The spiritualist movement was in full swing at this time. After the bloody Civil War—a devastating conflict in which thousands of men lost their lives in brutal and often pointless violence—people were looking for answers to what life and death meant. Séances became popular, as did the use of Ouija boards, ectoplasm, spirit tapping and tarot cards. Alice became a strong, devoted follower of the movement. There was a huge gathering of spiritualists in St. Augustine, and Alice mingled with many of the practitioners. She began to use her Ouija board again and commenced her communication with the voices that she claimed spoke to her from the grave. Exasperated, Henry sent her to yet another specialist. She threw a violent, angry fit and tried to stab the poor doctor with a pair of scissors. This was the last straw for Henry. In 1895, he had his wife declared legally insane and sent to an institution in New York State, where she would spend the rest of her life. Henry immediately tried to distance himself from the whole affair by attempting to have the marriage annulled. Unfortunately, there was no provision for divorce on the grounds of legal insanity in the state of Florida at that time. Henry Flagler, in true fashion of the powerful land barons of

the time, had the law legally changed. "Flagler's Law" stated that if it could be proven for four consecutive years that someone was "legally insane," then a legal divorce could be granted. This shows the powerful influence that Flagler had on the burgeoning state at that time.

What does this story have to do with the little village? Well, the place did not become Salerno until a few years later. Henry Flagler must have had some guilty feelings about what he had done to his wife, because the name he chose for the little flag stop by the Manatee Pocket was Alicia, after his stricken wife. The little fishing village was originally named for a person who claimed to "speak to the dead" on a regular basis. In her supposed madness, Alice was convinced that spirits wandered everywhere and wanted to communicate with her. Could Henry Flagler have been wrong about his wife, at least in part? Even though her behavior was erratic, could some of her claims have been true? Theirs was a different time, and the popular method of dealing with unexplained behavior or suspected madness was to simply lock people away. There is no doubt that Alice Shourds had unfinished business to attend to when she passed. Many people believe that her spirit watches over the place. Does Alice's lonely, misunderstood spirit wander the dark streets of her namesake village? Is she still searching for acceptance?

## Fishing History

For over a century, the Manatee Pocket has been the home to men of the sea. In its heyday, there were up to eight operating fish houses along the waterfront. Times were very good then, and mackerel fishermen brought in thousands of pounds per week. In the 1930s and '40s, a man named Charles Mooney ran a busy and profitable shark processing plant. His establishment sent huge numbers of shark fins west to San Francisco. The hides went to the Ocean Leather Company in New Jersey. Leftover carcasses were ground into hog feed and fertilizer and the low-quality oil sold to feed companies for livestock and poultry. The U.S. government bought large amounts of the higher-grade processed shark oil from the plant to be made into vitamins. It was a popular belief that vitamin A was excellent for eyesight, so it was given to pilots who flew night missions throughout the war years. Sport fishing as we know it today had its earliest origins in nearby Stuart. In the 1950s, Stuart, Florida, was known as the "Sailfish Capital of the World." As time passed, the commercial fishing business did experience some hard times,

as fish stocks waned, but it supported many families right up until 1995, when the bubble burst. The Florida purse-seine net ban went into effect, crippling the remnants of the fishing business in Salerno and other fishing communities. The number of commercial fishermen in Salerno dwindled, as many found other means of work. Today, there are still a few diligent fishing families that work the docks, but it is nothing like what it used to be.

# Local Spirits and Hauntings

## Pompano Chuck

Some of the locals were very colorful indeed, and it is widely believed that their spirits still haunt the docks of the only place they called home. One such fellow is a hermit who lived out on Hutchinson Island. His name was Pompano Chuck Solmer, and he was one of the best beach fishermen in the area. He seemed to have a spiritual connection with the fish and always caught more than he needed. Chuck would be more than happy to trade some fish for a nice, cold beer and a friendly conversation. He lived in an abandoned automobile and loved animals. He kept at least twelve dogs as pets, an arrangement that raised some eyebrows on the mainland. Some concerned citizens decided that they needed to conduct an investigation to find out if he was properly caring for the animals. They found out that he was, in fact, taking excellent care of them, and the investigation was dropped. In his later years, a wealthy friend had a small concrete house erected for him to live in, and he spent his remaining days there. Locals believe that Pompano Chuck's spirit lingers so that he can watch over the animals he loved so much in life. He is the animal spirit guide of Salerno.

## Dirty Freddie

Another eccentric spirit that walks the dark streets of Salerno goes by the dubious name of Dirty Freddie. In life, Freddie Gladwish was an educated

engineer by trade. After several years of work behind a desk, he decided that he could no longer stand the daily grind and surrendered his job and former life to become a hermit. He bought an old boat and anchored it near the Pitchford estate on Hutchinson Island. Freddie did not like to conform to the standards of the day. He didn't like to wear shoes. As a matter of fact, he didn't like to wear clothes, either. He only had one suit that he wore on Saturday nights when he went into town. He was there for one purpose and one purpose only: to find a woman. No one knows how successful he was at this because he took his secrets with him to the grave. One dark Saturday night, Dirty Freddie was walking along Indian River Drive in Jensen Beach when he was struck and killed by a drunk driver. His demise occurred so quickly that he most likely didn't know what hit him. It is widely believed that Freddie still comes to Salerno on Saturday nights to ogle at the many women who visit the restaurants and bars. Several ladies have felt a smooth hand gently stroke their arms or legs. Some have felt warm breath on their earlobes. One woman reported that a hand actually spanked her bum lightly! Freddie is harmless and seems to know enough to keep his distance most of the time. But this is a fair warning to ladies—be wary!

## Benjamin Mulford

In the early 1900s, Florida experienced its first land boom. Fast-talking salesmen from the North came down to deal in property, usually by any means possible and not always honestly. Any tracts along the railroad were fair game, and the little village that was originally known as Alicia was no exception. When, in 1910, a boisterous salesman named Benjamin Mulford arrived on the train, he found a tiny, underdeveloped and overgrown place that was bordered by a swampy hardwood forest to the west. Someone had changed the name of the place to Aberdeen for some unknown reason and then to Salerno. Mulford looked around, noticing that the place had a large waterfront, and began to formulate a plan. He immediately went to the land office in West Palm Beach and purchased six thousand acres of what is today known as south Stuart and Port Salerno. From there he went on a quest to promote sell what he called "Utopia." He immediately returned to his hometown of Minneapolis, Minnesota, and convinced several people he knew to invest in his dream and move to the area. He then surveyed the land west of the village and divided a large sum of it into ten-acre lots. In

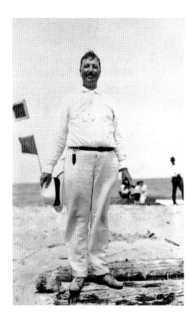

Benjamin Mulford, father of Salerno. *Courtesy of Martin County Historical Society–Elliott Museum Collection.*

the village itself, he split his holdings into adjacent 150.0-foot by 47.5-foot lots. He printed extravagant brochures and sent them all around the country, advertising the western lots as "St. Lucie Inlet Farms." Anyone could have one of them for the paltry sum of $1,000, and Mulford would even throw in one of the smaller town lots as an incentive. Yes, Mulford had huge plans for the place, even pitching an idea to dredge the Manatee Pocket so that it could accommodate very large vessels and widen the St. Lucie River all the way to Lake Okeechobee. His enthusiasm and vision paid off, and many people came.

He even renamed the village after himself. The village of Salerno became the village of Mulford. This fourth name of the place would prove to be short-lived when a woman traveling on the railroad thought the conductor had shouted "Fulford" and got off the train. Fulford was actually much farther south, near present-day Aventura, Florida. The poor woman was left alone in little fishy Mulford, where she was immediately beset by gnats, mosquitoes and sand flies. When the incident was resolved, she was so angry that she threatened to sue the railroad. That was when two prominent residents of the village, E.J. Ricou and Hugh Willoughby, decided to change the name back to Salerno.

# THE MULFORD HOUSE

## *Pirate's Cove Resort*

Benjamin Mulford built his family a fine house on the waterfront in Salerno. The road in front of the place is actually named Mulford Street after the man himself. It was the largest and most elaborate home in the village. The Mulford House was a two-story wonder with a swimming

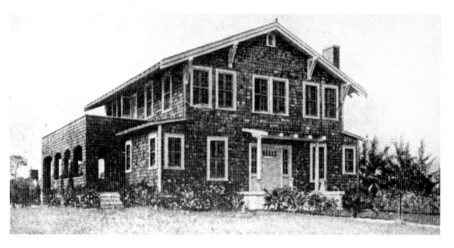

Benjamin Mulford's home on the waterfront where the Pirate's Cove Resort sits today.
*Courtesy of Martin County Historical Society–Elliott Museum Collection.*

pool out back and a glorious view of the river. In later years, it became the first resort in the area. The building was eventually torn down and replaced with a modern structure, the Pirate's Cove Resort, which is a beautiful place for boaters and land travelers seeking the Florida experience. The area where the original swimming pool was located is now covered by a bar with a large dance floor. The first story underneath the bar is now the resort store. Several people who used to work there have reported that they have had some strange experiences late at night after closing. When they entered the space toward the rear of the store, they sometimes experienced the sensation that they were not alone. Some said that they were sometimes touched by invisible hands. One man even said that he was actually shoved hard, causing him to nearly fall down. The site has actually had several renovations since Mulford's time, but many people believe that he still claims ownership of it. One couple reported seeing a man strangely dressed in old-fashioned garb walking past them on the grounds. He bowed to them, smiled and very politely tipped his straw hat. After he passed them, they turned around to take a second look. The man had vanished, as if into thin air. Does Benjamin Mulford still watch over the place he loved so much in life? Does he feel the need to protect it?

# THE LADY IN WHITE

There is a legend about an event that happened in the area just north of Salerno known as Golden Gate. It involves a documented haunting that has been reported by many people over the years.

Back in the 1920s, the area around Salerno was a far different place than it presently is. The road that ran along the railroad tracks between Stuart and Salerno was nothing more than a sand trail. Legend has it that a young couple, Roger and Mary, had just gotten married in Stuart. It was a grand affair, with both of their families present in great numbers. It was a joyous occasion, and everyone involved had the time of their lives. The young couple smiled at all of the guests and happily climbed into their Model T Ford, anxious to begin their wonderful journey of life together. Their plans were to drive from south Stuart to Salerno, where they would get on the train and head south to Palm Beach for their honeymoon. It was a moonless night, so by the time they began the short trip to the train station, it was very dark.

At that time, there was not much awareness about things like pollution or environmental damage. People who rode the train had no issues with discarding unused trash from the windows as they sped along. Men drank their whiskey in small flasks made of thick glass. These were routinely discarded along the way. That is why experienced bottle hunters find the best specimens along old railway stops.

As the young, happy couple made their way south in their car, the wind picked up and the temperature suddenly dropped. A violent rain shower quickly moved in, depositing sheets of water so thick that Roger could hardly see where they were going. Through the blurry windshield, he saw the lights of the train coming in the distance, so he slowed down. The train was soon thundering past them, the wind created by its huge weight rocking their car gently as it passed. It was a long one, hauling both passengers and freight north.

In one of the railroad cars, a businessman yawned. It had been a long, tiring journey. He raised his whiskey flask to his mouth and in one gulp finished it off. He then reached up with one hand and pulled the cab's single sliding window open, immediately feeling the moist night air on his face. Looking out, he watched the countless palmetto trees whizzing by like fence posts through the rain as the train sped along. He stood up, cocked his arm back and heaved the bottle through the open window as hard as he could. The bottle sailed through the air, bouncing off a

tall palmetto and then careening toward the roadway, directly into the path of the Model T.

Roger was totally surprised by the sound of breaking glass in front of his face. He quickly looked over at his young bride, who stared at him with an expression of fright and surprise. It happened so suddenly that Roger lost control of the vehicle, spinning off the road toward a stand of tall trees. The car smashed headlong into the largest of them, coming to an immediate stop in a mass of twisted metal and broken glass. Roger, stunned and bloody, managed to push his door open and stumble out into the driving rain. His head had smacked into the steering wheel, and his face was covered in blood from a wound on his forehead. Disoriented and dizzy, he stumbled through the tall grass around the front of the car to

Statue of Port Salerno fisherman carved from a eucalyptus tree stump by the fishing docks in Port Salerno, Florida. *Authors' collection.*

the passenger side. He wrenched open the door of the car and encountered a heartbreaking sight. There lay the limp, blood-covered body of his wife, Mary, still in her wedding dress. The young girl had not survived the crash.

Apparently, the terror of the night lives on. To this day, many travelers have reported seeing something very strange along the highway between the communities of Salerno and Golden Gate, just to the north. Late at night, after the bars and restaurants have all closed, they see the figure of a woman walking along the shoulder of the road. She is crying, and her white wedding dress is stained with blood. Her life ended so quickly and tragically that she never knew what hit her. She wanders the streets at night searching for her husband and the life that she never got to experience. She is Mary, the lady in white.

# HOBE SOUND

## 18

# THE ABANDONED CEMETERY

A short distance off the beaten path in southeast Martin County is a spot that not many people know about. This is a tale that the authors heard about the place a while ago while sitting around a blazing campfire. The man who told it swears that his experience is true.

A man named Jim stumbled across a burial ground a few years ago in the small community of Hobe Sound while he was "geo-caching." This is a popular pastime in which people use a global positioning satellite (GPS) app on their cellphones to find treasures hidden by other "geo-cachers." This particular day, Jim was searching for a particularly difficult cache in a thicket of overgrown weeds in between some train tracks and a housing development. It was very hot, so he paused frequently to drink water from his canteen. As he struggled to pull himself free from some weeds, his foot ran into something very hard. He looked down and was astonished to see the rough, light-gray surface of a tombstone. Surprised, he bent down to clear the vegetation away. He could see a name scrawled on its surface, but it was so faded that he couldn't make it out. The engraving was rough and amateurish. He then looked at the area around him. He soon found three more stones with similar markings. It became obvious that he had stumbled upon an abandoned graveyard. A cold chill went through his spine, so he gathered his things and left the place. It was just too weird for him.

As Jim drove home, he wondered about his discovery. What was a graveyard doing in such a public place? It was almost as if society had completely forgotten about it and built everything around its perimeter.

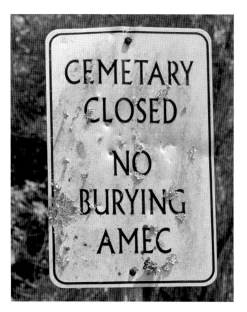

Gomez Cemetery, Hobe Sound, Florida. *Authors' collection.*

As the years passed, the weeds took over, and the headstones were swallowed up by the landscape—lost in time forever. The more he thought about it, the more uncomfortable it made him. What about the families of the people buried there? Did they even know of the final resting place of their relatives? He decided to do his own research and tell no one about his discovery until he knew more.

At the local library, he learned that nearby Jupiter Island had long been home to some of the most affluent people in the country. Back in the early part of the twentieth century, most of the hired help who worked on the lavish estates resided on the mainland. The place was originally called Gomez, named after the original Spanish land grant recipient over one hundred years earlier. Most of the land around Gomez and the railroad was swampy, mosquito-infested and undesirable. At that time, there was a community of mostly African American people who lived in the area by the tracks just north of the main road that led to Jupiter Island. It was around the time of the Great Depression, and no one, save for the bluebloods on the island, really had any money to spend. Besides, it was too hot and buggy in the summer for any Yankees to want to live there. Jim Crow was still the de facto law in the South, so black people were kept segregated from just about everything. It was a different time, and people kept to themselves, falling into roles that had been established hundreds of years earlier. Every morning, they either walked or drove their old cars and trucks out over the rickety steel drawbridge that was there before the modern-day concrete structure you see today. Many of those families had worked for their wealthy employers for decades and were very comfortable and good at what they did. They would work all day long and then drive or walk back out to the bridge to go home to their village along the tracks. Their children were born, grew up and often died in the same place they had been their whole lives.

They also worshipped together. In his research, Jim discovered that there had once been an African Methodist Episcopal church near the site. The members marked out their own cemetery plots near the church, burying their dead and marking the graves with hand-hewn stones, many of them decorated with poignant messages of grief. A number of years later, the church was burned to the ground by vandals, leaving only the lonely little graveyard. As time passed, more and more people moved to the area from up north. The land along the railroad tracks was bought up, and housing developments, trailer parks, strip malls and gas stations were built. Lots were sold to newcomers, and new homes were built. Somehow, the little cemetery slipped between the cracks, eventually becoming overgrown with vegetation. There was no reason to enter into the seemingly abandoned area, so very few people even knew it was there.

As Jim contemplated all of this, he wondered about the place more and more. For some reason, he felt that he had to go out to the site one more time. Donning his hiking boots and opening the back door of his Jeep for his small beagle, Jip, he drove the short distance to the abandoned graveyard. It

"Remember Me." Gomez Cemetery, Hobe Sound, Florida. *Authors' collection.*

was late in the day, and the sun was orange and lowering in the western sky. He walked to what must have been the entrance to the place. Jip ran over to some bushes as if he saw some small animal dart away. Jim ignored the dog, concentrating on locating more headstones in the weeds. He bent to one knee and examined a leaning cross-shaped stone.

It had an inscription on it: "She was a kind, affectionate wife and a fond mother and a friend to all."

Jim's eyes teared up as he read it. It occurred to him what a sad little place it was.

Just then, he heard Jip bark and run out of the graveyard toward a thick stand of trees. Jim called out, but the dog ignored him. He strode toward the trees quickly. All he could see was Jip's rear end and his tail wagging as he busily dug at something in the weeds at the base of the trees. Jim scowled as he reached down to grab the dog's collar and pull him out of the hole. When he pulled Jip back, he noticed something lying on top of the sand that Jip had exposed. He fell to his knees and looked closer, feeling his blood run cold as he realized what it was. On the ground before him was a small human skull.

He paused for a moment, not knowing what to do. Briefly looking back toward the graveyard, he tried to make sense of what he was seeing.

Where had it come from? It couldn't be from the cemetery. The bones would be too deeply buried for an animal to get to. There were no other bones around it to indicate that it was part of a crime scene. It was just lying there, its gaping eye sockets looking off at the ground past him.

He looked at the skull for a long moment. It was pretty well worn, so it probably wasn't very fresh. Jim's heart sank as he realized something about it. Its small size indicated that it might be that of a child. Without thinking, he reached out and picked it up. He simply couldn't leave it there for an animal to carry off. He walked back to his Jeep, the skull in one hand, as Jip bounded after him, his tail wagging happily. He found a burlap sack in the back and carefully placed the skull inside. He then wrapped it up and gingerly laid it on the back seat floor.

As he drove home, he thought about what he had found. Why had he picked it up? The magnitude of what he had done came to him all at once. He cursed himself for making spur-of-the-moment decisions without thinking them through.

What in heck was he going to do with it?

What if he got pulled over for a busted tail light, and the cop wanted to know what was in the bag?

"Who am I?" Gomez Cemetery, Hobe Sound, Florida. *Authors' collection.*

As he drove along, his mind spinning, another feeling came over him. He suddenly got the feeling that he wasn't alone in the car. Jip suddenly leapt up on his hind legs with his paws on the seat and started to bark loudly at something in the back seat. Jim could feel fear rising inside of him and the hair stand up on his arms.

What was the dog barking at?

He glanced into the rear-view mirror to see if any other cars were following him. Just as he did that, his eye caught something. There, in the edge of the rear-view mirror, was black hair, with bits of leaves and dirt in it. Someone was sitting in the back seat!

Jim panicked and shouted out in fear. As he wildly spun the steering wheel, sending the Jeep into a spin, Jip sprang up, staring at him in confusion. Jim slammed on the brakes and skidded to the side of the road, where the Jeep came to a stop. He immediately spun around and looked at the back seat.

Nothing was there. Jip barked at him.

Jim just stared at the empty seat. Someone had been there. It was a small person with black hair. He was sure of it. After several minutes, Jim settled

down behind the wheel resignedly. He must have been hallucinating. He was tired and needed to get home. He started the Jeep and pulled back out onto the road toward home. He reached over and gave Jip a generous scratch on the head.

That's when he heard the voice. It was just a whisper, but it was there.

"Take me home."

Jim nearly jumped out of his skin. He immediately hit the brakes and whipped the car around, doing a hard U-turn in the road. He then sped back in the direction he had come. When he got there, it was dark, but he could see well enough to do what he had to do. Within minutes, the skull was far underground, safe from harm and far away from him. Jim and Jip then left the abandoned cemetery, never to return again. He will never forget that day as long as he lives.

# 19

# TRAPPER NELSON'S CAMP

In western Jupiter, near the Martin–Palm Beach County border, you will find one of the most intriguing historical tourist attractions in the state. If you begin your journey at the Riverbend Park boat launch in a kayak or canoe, you will find yourself transported to a Florida that is rarely found today. As you maneuver your craft around the narrow, winding river, you will be stunned by the natural beauty you behold. There are immense cypress trees some five feet thick at their bases, their branches draped with tendrils of low-hanging sphagnum moss, and towering Florida pines with tops so high that they are nearly hidden in the dense, overhanging canopy that almost completely shades the sun. The clear, tannic water is so shallow in places that you may have to get out of your craft and pull it behind you until it gets deeper. As you glide along, you may catch the eye of a motionless alligator as it rests on the bank, waiting ever so patiently for its next meal. There will be an amazing array of birds, including red-headed woodpeckers hammering their strong beaks persistently against the sides of hardwood trees and graceful great blue herons. If you're very lucky, you may even catch a glimpse of a majestic bald eagle. And you will see many turtles. The river's name, Loxahatchee, is a corruption of the Hitchiti name *Locha-Hatchee*, or "River of Turtles." A few miles upstream, as you make a sharp turn in the river, you will see a makeshift dock with a rough, corrugated metal roof surrounded by tall, thick stands of bamboo trees. You have just entered the world of Trapper Nelson.

Trapper Nelson's dock. *State Archives of Florida, Florida Memory.*

## THE DRIFTERS ARRIVE

According to the well-researched and popular book *Life and Death on the Loxahatchee,* by historian and author James D. Snyder, it was in the late 1920s when Vince Natulkiewicz and his brother, Charlie, got off the train in Jupiter. It was during the Great Depression, so there were a lot of drifters like them "riding the rails." They were accompanied by a friend, John Dykas, whom the two brothers had known since childhood. The trio liked the look of the place so much that they decided to stay. Frustrated by the strange looks they got when the locals asked them who they were, the brothers decided to change their last name to something that was easier to pronounce. They became Vince and Charlie Nelson.

The trio camped near the beach and spent the next few months trapping in the local waterways. As time passed, tension grew between Charlie Nelson and John Dykas. Both of them were headstrong, opinionated men, and they began to have disagreements about their future plans. Tempers came to a

Trapper Nelson with a young man in a boat on the Loxahatchee River. *State Archives of Florida, Florida Memory.*

head one evening, when Charlie, in a fit of anger, shot John Dykas, killing him instantly. Charlie then drove himself to the nearest police station in West Palm Beach and turned himself in, admitting to the murder right away. News of the incident spread quickly through the area. Both Vince and Charlie were immediately arrested and put in jail. There was a highly

publicized trial, and Justice Chillingworth, the judge in the town of Jupiter at that time, sentenced Charlie Nelson to twenty years in prison for the crime. Young Vince actually sided with the law against his brother, because he had liked Dykas. As he was being hauled out of the courtroom, Charlie "Nelson" turned and glared at both his brother and the judge who sentenced him. In a fit of rage, he vowed to come back someday and kill them both. The law then took Charlie away.

Young Vince was left to fend for himself. Disillusioned at his bad fortune, he made the decision to venture far up the river into the wilderness alone to set his traps. He was an experienced trapper and woodsman and liked the availability of wildlife on the Loxahatchee. As he worked his trap lines, he stumbled upon an abandoned hunter's cabin. It was the ideal location for him right on the river, so he chose to call it home. He immediately started to clear the land, cutting down trees to make improvements.

Vince was an imposing figure at six feet, four inches and 240 pounds. Social interaction was not his strongest point, so he preferred to be alone. At first, his New Jersey roots worked against him with some of the locals. He gained a reputation with other trappers as being very good at his trade, but he faced some prejudice and animosity due to the fact that he was not a native Floridian. He would chop a cord of firewood every single day, soon ending up with a massive stack sixty feet long and over ten feet high. Every day, he would diligently make his way down the swampy mangrove-lined river to check all of his traps. Vince was excellent at catching raccoons, otter, bobcats, opossums and alligators. He ate practically everything that he trapped, including bobcats, gopher tortoises and even snakes. People began to refer to the reclusive giant as "Trapper Nelson."

## TARZAN LIVES

As time went by, people would travel down the river to visit Trapper's camp. He would greet them at the crude dock with an entourage of dogs, raccoons and other tame animals that he cared for. Oftentimes, he would be wearing a long, thick indigo snake wrapped around his shoulders. At that time, the movie *Tarzan* was very popular, and people began to compare Trapper to the "King of the Jungle." In the late 1930s, a fisherman from Canada named Fran Lechleitner bought a large tour boat, the *Nine Bells*, that seated about thirty people and began to take people up the Loxahatchee River for scenic

tours. The destination was Trapper Nelson's camp, and the big man played his Tarzan role to the hilt. By 1937, the tours had grown so much in popularity that he decided to venture into show business. He named the place Trapper Nelson's Zoo and Jungle Garden and started to charge admission for the show. He made many improvements to the place: sprucing up the animal pens, installing crude bathrooms and erecting a few more buildings. Wealthy people from Jupiter Island appreciated the place as a wondrous trip into the Amazon-like jungle to visit the "Wildman of the Loxahatchee."

One of Trapper's closest friends and fishing buddies was, surprisingly, Judge Chillingworth, the same man who had sentenced Trapper's brother, Charlie, to twenty years in prison many years earlier. It was said that they held weekend card games at Trapper's camp that were often attended by the most important politicians and lawyers from Palm Beach and Martin County. It was from some of his friends that he learned how to speculate in tax delinquent land deals. Trapper eventually acquired the title to eight hundred acres of land along the Loxahatchee River, including the land on which he lived. He claimed that it was "gifted" to him by Judge Chillingworth himself. No one will ever know the truth, because Judge Chillingworth was brutally murdered in 1954.

Trapper Nelson's guest pavilion, Jonathan Dickinson State Park. *State Archives of Florida, Florida Memory.*

In 1942, Trapper got married after a hasty courtship to a woman named Lucille Gee, whose intentions were questionable right from the start. When World War II came, even Trapper Nelson was not exempt from service. He received his draft notice, learning that he was to be sent to Texas for basic training. The newly married couple agreed that Lucille would stay behind and watch over the place until he returned. During his service, Trapper sustained a serious injury to his leg while exercising that left him with a scar and a slight limp for the rest of his life. He was then miraculously transferred back to Camp Murphy, today known as Jonathan Dickinson State Park, in Hobe Sound, Florida, which was adjacent to the eight hundred acres of land that he owned. At the time, some people felt that the influence of his wealthy customers from Jupiter Island had something to do with the choice to relocate him to that particular spot. During his short absence, his wife, Lucille, had predictably run off with another man, so he found himself alone again to do as he pleased. Camp Murphy was a top-secret radar training facility that housed over eleven thousand personnel. Nelson served out his time as an MP, cruising the borders of the place in search of intruders. He was able to keep trapping and continued to host the Saturday night card games at his camp for several local officials and politicians. Some say that this is how he made the money to buy even more land at rock-bottom prices.

## ENTREPRENEUR

During the 1940s and '50s, Trapper Nelson's Zoo and Jungle Garden grew even more popular, attracting famous visitors like Gary Cooper, Patricia Neal, the Duponts, Wendell Wilkie and Gene Tunney. The place became one of the major tourist destinations for the growing throngs that were flooding into the area at that time. While this was happening, Trapper continued to buy more land at tax auctions, increasing his holdings to over 1,100 acres. Boy Scout troops would go to the camp to stay overnight. At the end of the day, Nelson would herd them all up the roughly hewn ladder into the loft of his large Seminole-style *chickee* and then take the ladder away so they would stay put until morning. At the dock entrance, he kept a long rope tied to a tall cypress tree and would swing out over the boats as they came near, crystalizing the Tarzan image he found to his liking. Visitors to the camp would gape in astonishment as Trapper would sometimes slit a gopher tortoise's neck and drink the

blood, the whole time extolling the virtues of "natural nutrition." Things were very good for the big man in those days.

Then all of that began to change. In 1960, he abruptly closed his zoo. His behavior transformed dramatically, and people began to notice a different side of the "Wildman." He placed "no trespassing" signs along the river, some of them warning of the danger of land mines should potential visitors come too close. He cut down tall trees to block the river. What had happened?

There seem to be many reasons for Trapper's change of heart regarding outsiders. The area around his property was growing at leaps and bounds, and threats of impending development made him nervous. There were a lot more people around, with hikers, boaters and hunters showing up on his land with increasing frequency. He was harassed by teenagers who spied on him from the trees and played tricks on him at night. Then there were the government regulators who showed up at his zoo for unannounced inspections. They started to impose fines on his operation. The bathrooms weren't up to code, the animal cages weren't sanitary and an insurance bond was required for the venomous snakes that he kept; the list started to grow and grow. Trapper grew paranoid of litigation should someone be injured on his property. His view of the outside world began to sour.

There was also the problem of the growing tax burden on his land. He could not keep up with the financial increases that were facing him, and he was forced to borrow money. For years, he had to fend off creditors, a task that made him even more distrustful of people. Then, in 1968, a large development company approached him. Soon there was a good land deal pending, but he was dismayed to learn that he was being sued by his ex-wife who, on learning of the deal, wanted her share, even though she had left him many years earlier. He was getting older, and his stomach bothered him all of the time. He was convinced that he had colon cancer but refused to get proper medical attention. By July 1968, Trapper Nelson was using a catheter to urinate.

## TRAGEDY IN THE JUNGLE

On July 30, 1968, Trapper Nelson failed to show up for a lunch meeting with an old friend at the home of John and Bessie Dubois at Jupiter Inlet. Sensing that something was amiss, John Dubois checked at the post office in Jupiter to see if Trapper had picked up his mail. When he learned that his friend

hadn't been in for over a week, John made the journey out to Trapper's camp. As he looked around, he was assaulted by a very bad smell. He then made a grisly discovery by the large pavilion near the docks. Trapper's lifeless body was lying facedown in the sand. His twelve-gauge shotgun lay a few feet away. There was a large hole in his chest, and most of the back of his head was missing. The guinea hens, raccoons and maggots were doing the rest.

The death was ruled a suicide, but many people had valid questions. First of all, how could someone shoot himself in the chest with a shotgun? Wouldn't a pistol be easier? One would have to use his or her big toe to push the trigger. Also, there were no footprints at all found around the crime scene. Wouldn't Trapper himself have left footprints? Did someone wipe them all away with a branch? Another unexplained detail was that the slug that killed Trapper did not match the one left in the opposite barrel of the shotgun. Trapper Nelson had grown up around firearms and handled guns his entire life. Why would he be so careless? He was very close to closing a very lucrative deal for his land that would have left him a millionaire. He did have a few enemies, but nothing was ever proven. One of his greatest enemies was his own brother, Charlie, whom he had helped send off to prison. Court records showed that Charlie had been released in 1951. The bottom line was that Trapper Nelson was gone forever.

Or was he?

## THE LEGEND LIVES ON

Many people feel that Trapper is still there. According to *The Haunt Hunter's Guide to Florida*, by Joyce Elson Moore, the ghost of Trapper Nelson actually spoke to a new park ranger in training named Sheryl Wells at the camp in 1994. She heard a man's voice clearly.

"If I weren't dead, I'd be asking you out."

No one else had heard the voice. She turned and asked the ranger with her a question. "Was Trapper a ladies' man?"

"How did you know that?" he asked.

"He's here, and he's flirting with me," she answered.

Another time, as she was perusing information on his death in her office, Trapper's ghost actually appeared to her in a full-body apparition. She thought that he wanted something, but it wasn't clear what it was. She was so concerned that she requested the services of a psychic medium to come

Inside Trapper Nelson's house, Jonathan Dickinson State Park. *State Archives of Florida, Florida Memory.*

out to the site. The medium made contact with Trapper and delivered a message to the ranger from him. She said that Trapper Nelson's spirit was concerned about two burials on the grounds, possibly Native American, that he wanted kept safe.

Many people have reported paranormal experiences near the place. Two kayakers reported seeing Trapper waving to them from the dock as they drew near. When they inspected the camp, no one was there. Many have heard a man's voice speaking by the cabins late at night, barely audible over the breeze blowing through the fragrant Florida pines, and some have heard the sounds of heavy boots crunching through the trees near the camp.

One day, when state workers were doing renovation on the main cabin, they found a loose brick in the fireplace. When they removed it, they were shocked to find five thousand coins stashed inside. As they were retrieving the coins from the cabin, they were repeatedly dive bombed by two furious, shrieking ospreys. Ospreys do not act like that normally, so the workers grew very nervous. Was someone angry about their find?

His apparition has been seen many times on the rough roadway leading into the camp. A few of the residents who live nearby have seen him looking in their windows. His image has a strange light around it. It is widely believed that a benevolent, strong spirit still watches over Trapper Nelson's Zoo and Jungle Garden. We recommend that you visit the place yourselves and make up your own mind.

# JUPITER

# JUPITER INLET AND LIGHTHOUSE

Our present culture has only been here in South Florida for a very short time. It has only been five hundred years since Europeans landed here and less than one hundred since the majority of people flocked to live here after the introduction of air conditioning. In the time before European contact, there was a completely different population that inhabited the area around present-day Jupiter Inlet in Jupiter, at the southern end of what is now known as the Treasure Coast. When people think of Florida Indians, they think Seminole. The truth is that there were multitudes of native people along Florida's coast who were there thousands of years before the Seminoles started coming into the territory in the late eighteenth century. The tribe at Jupiter Inlet was known as the Jeaga, a sub-tribe of the mighty Ais people to the north. Almost four thousand years ago, they lived near the beach, subsisting on shellfish from the river, saltwater fish from the ocean and many other food sources that were readily available. These native people were not very good housekeepers and discarded their empty shells, bones and any other refuse on the ground under their feet. The vast size of the Jupiter Inlet mound is an indication of the importance of the place. According to Spanish and pioneer accounts, the midden was originally nearly a mile long, stretching all the way from the ocean to the area where the U.S. Highway 1 bridge now sits. For years, much of the shell-based material was harvested as bed material for Henry Flagler's railroad and for driveways and roads.

## INDIAN GRAVEYARD

The Jeaga buried their dead near the present location of the Jupiter Lighthouse. In 1885, there was an excavation team on the north side of the U.S. Coast Guard Station that reportedly found several Indian burials. There are many more documented burial mounds in surrounding areas on both sides of Jupiter Inlet. Only in recent years has awareness of these Indian burial sites become important. How many unreported sacred graves were upturned for the sake of development? Are the spirits angry at this gross violation of their final resting places?

It is believed that the great explorer Ponce de León made a landing at Jupiter Inlet. His men warily rowed into the narrow waterway, soon making landfall to survey the terrain. They were surprised when a party of Jeaga warriors attempted to steal their longboats and weapons, and a violent encounter ensued. Two of Ponce's men were wounded by arrows. When the natives were temporarily repulsed, the Spaniards ventured farther up

Dubois House, erected on top of an Indian midden at Jupiter Inlet. *Authors' collection.*

into the Loxahatchee River in search of firewood and supplies. Ponce de León wrote that they then placed a stone cross marker somewhere along the shoreline as a symbol of claim, naming the place *Rio de la Cruz*, or "River of the Cross." When the hostile Jeaga warriors resumed their attacks, the Spaniards left the inlet, sailing farther south in search of friendlier subjects to convert to Catholicism. The cross they left has never been found.

# 21

# 1696

## THE JONATHAN DICKINSON SHIPWRECK

Jonathan Dickinson was a wealthy planter's son from Jamaica who provided us with the best description we have of the Jeaga people. He and several members of his group were Quakers—a group that had split from the Church of England—and they were on their way to join the Quaker community in Philadelphia. In his well-known journal, *God's Protecting Providence*, published in the year 1699, Dickinson recounted the trials he and his party endured after a storm crippled their vessel and ran them aground on the shoreline of present-day Jupiter Island.

After the passengers and crew were spilled out onto the desolate beach of southeast Florida, they were immediately attacked by two Jeaga warriors. These "furies," as Dickinson referred to them, were running fiercely and foaming at the mouth and seemed to threaten them with dark violence. Dickinson temporarily appeased them with gifts of pipes and tobacco, which they snatched from his hand and then ran off into the scrub. Much to the survivors' terror, the two Jeaga visitors soon returned with many more warriors. Just as they were about to execute the party, the natives had a sudden and miraculous change of heart, abruptly deciding not to kill them. Dickinson was convinced that it had been divine providence that caused their knives to abstain from the bloody task, but it may have been due to the fact that one of the crew members, Solomon Cresson, spoke fluent Spanish.

Initially, the Ais men had been sure that these pitiful shipwreck survivors were *Nickaleer*, the Jeaga term for the English. The Jeaga and the Ais people were already very familiar with the harsh brutality of Spanish soldiers, and

when they heard the familiar tongue being spoken by one of these strangers, it may have put the seed of doubt in their minds. The Spanish had already told them that if they encountered any English shipwreck victims, they were to put them to death. But what if they killed Spaniards by mistake? Then the vengeful Spanish would certainly come.

The Dickinson party was roughly hustled down the beach to the south for about five miles, to the place now known as Jupiter Inlet. Dickinson wrote of a large settlement there of thatched "wigwams." He wrote of a strange event that he and the others witnessed at the place where the Jupiter Lighthouse stands:

> *Night came on: the moon being up, and* [an] *Indian, who performeth their ceremonies stood out, looking full at the moon making a hideous noise, and crying out acting like a mad man for the space of a half an hour; all the Indians being silent till he had done: after which they all made fearful noise like the barking of a dog, wolf, and other strange sounds. After this, one gets a log and sets himself down, holding the stick or log upright on the ground, and several others getting about him, made a hideous noise, singing to our amazement; at length their women joined consort, making the noise more terrible. This they continued till midnight.*

A bright, unexplained orb on the bed in the Dubois House, which rests on the Jupiter Mound. *Authors' collection.*

For how many thousands of nights had this achingly devout ritual been held? Does the energy and raw emotion of these people still linger on that holy ground? It is believed that for thousands of years, native people gathered on the high natural sand dune where the Jupiter Lighthouse now stands to worship the night sky. To

this day, many people have heard strange noises on the grounds in the dark of night. Are their strong spirits still there? Does their powerful otherworldly energy still permeate the very ground? There is a strong possibility that the Jeaga may have practiced a form of ritualistic cannibalism of their enemies, as did the Calusa on the west coast and the Ais to the north. What sort of residual energy is still present from such an archaic, brutal practice?

Jonathan Dickinson recorded that he and his people were held at the great village at Jupiter Inlet for an entire month. The bedraggled survivors, by this time exhausted, frightened and malnourished, were finally released and allowed

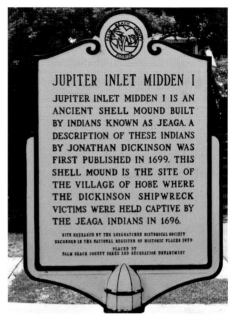

Historical marker at Jupiter Inlet Mound. *Authors' collection.*

to plod north along the beach, eventually coming to a massive Ais settlement. According to his maps and accounts of the distance they traveled, the village, called *Jece* by the natives, was located on the barrier island somewhere between the Sebastian Inlet and northern Vero Beach. Dickinson describes a frightening ritual in which the "Indians have a ceremonious dance" on the beach. He states that they "painted themselves, some red, some black, some with black and red," and gathered around an eight-foot-long ceremonial pole "halfway painted red and white like unto a barber's pole." The helpless survivors then watched as the terrifying natives shook rattles, danced and howled for three full days and nights. They would continue dancing until they passed out from exhaustion, only to continue after a short rest.

The Dickinson party was eventually released and allowed to continue their miserable journey. Along the way, they were constantly harassed by the Indians, who shot random arrows at them and threw rocks from the scrub. Several of them eventually perished from exposure, cold and malnutrition. Three slaves—a man named Jack, a woman named Quenza and her child, Caesar—were among those who lost their lives on their arduous trek north. They had lagged far behind the main group and took refuge from the cold,

biting winds near some exposed rocks. After stopping to rest from hunger and sheer exhaustion, they simply could not go any farther. They lost their lives there in that lonely, desolate place.

## SPANISH GALLEON WRECKS

There are two Spanish treasure shipwrecks that have been recently located in the sea near the Jupiter Inlet. The *San Miguel Archangel* and the *San Franscisco y San Antonio* were both small messenger ships in the 1600s. They were known as *avisos* and constructed for speed rather than for hauling freight. In 1987, two surfers reported that they had seen what looked like a cannon in the sand a short distance from the shoreline. A short time later, a lifeguard on duty there located the artifact and confirmed what it was. He notified a local captain who owned a marina and showed him where the cannon was. The two men formed a partnership and began to informally probe the delicate wrecks. They found many valuable items of historic importance, but the most amazing find was a giant silver bar that weighed seventy-eight pounds. After a lengthy battle with the State of Florida over salvage rights that eventually resulted in a compromise, the research and formal salvage effort began in earnest.

Once the wrecks were identified by a process of examining Spanish letters and documents of the era, a darker story began to emerge. Some believe that the shipwreck victims of one or more of these ships were carrying disease. The wrecks would have been right in front of the then-thriving Jeaga community, so a collision of Indian and Spanish would have been inevitable. Records show that the natives experienced a terrible plague shortly afterward that nearly decimated their numbers. The misery, suffering and loss of the Jeaga would have taken place right there where today's speedboats, fishing vessels and jet skis fill the air with the sounds of motors.

# A BEACON IN THE DARKNESS

After the Battle of Loxahatchee in 1838 during the Second Seminole War, the U.S. government wanted to investigate the use of the natural inlet at nearby Jupiter. The army sent the U.S. Corps of Engineers to investigate the site, and the recommendation was made. It is believed that a young engineer was with them named Robert E. Lee. After President Franklin Pierce approved the project in 1854 for the price of $35,000, the lighthouse design project was given to an up-and-coming lieutenant named George Gordon Meade. It is ironic that these two men would cross paths many years later as opposing commanders at the Battle of Gettysburg in the Civil War.

Construction of the lighthouse began immediately, but problems soon arose. The site was very difficult to access with the three hundred tons of materials need to complete construction. Southeastern Florida was a very different place at that time. None of the land had been drained with canals like it is today, and swamp-like conditions were the norm. Clouds of mosquitoes, torrential rain for days on end and blistering heat tormented the men who worked there. It seemed that the place was cursed. One night, a bad storm blew in from the ocean and pounded the workers for hours. The men awoke to find that the inlet had closed off completely. It was as if some unseen malevolent force was working against them. It soon became impossible to bring any building materials in from the sea. The inlet became a pool of stagnant, malodorous water that was a breeding ground for mosquitoes. Many of the men got sick with what they referred to as "Jupiter Fever," an affliction that may have been malaria. Also, tensions with

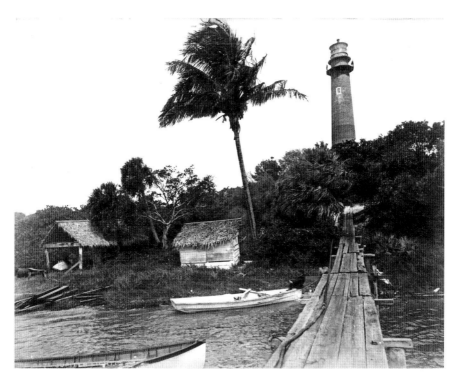

Lighthouse, Jupiter Inlet, Florida. *State Archives of Florida, Florida Memory.*

the Seminole Indians had once again exploded, and a new war ensued. The situation grew so dire that construction was halted completely.

At the conclusion of the Third Seminole War in 1858, construction began again in earnest. All of the materials had to be brought in from the river side on small barges, but construction was quickly completed. A keeper was hired, and the powerful Fresnel lens cast its first guiding beam out to sea in 1860. Not long after, the country broke out into the Civil War, and the lighthouse was temporarily darkened when some Confederate sympathizers stole the lens from the tower and hid it. After the war ended, it was returned to its proper place and has shone brightly ever since. The most well-known lighthouse keeper was a man named Captain James Armour, who would diligently hold the important position for the next forty years.

## 23

# SPIRITS AND HAUNTINGS

Rarely in the history of the Treasure Coast has there been a place where more significant historical events have occurred. Tragedy, sickness, extreme hardship, sorrow, joy and untimely death have all been experienced in this place at one point or another. Are the Jupiter Inlet site and the lighthouse haunted? It depends on who you ask. Many of those who protect the place tenaciously deny it. Still, many others swear that there is paranormal activity within the thick walls of the lighthouse and its surrounding buildings. Visitors to the place have experienced strange cold spots as they slowly make their way up the long spiral stairs toward the light. Both employees and guests of the site have seen formless, shadowy apparitions on the grounds, especially near the ancient shell middens that still lie on the property and around the inlet. Many have reported being lightly touched from behind, only to turn and see that no one is there.

There is a legend that persists to this day concerning the Dickinson party. On rare days when the wind is low and the clouds cover the sun, many people who have been out walking on the beach have heard strange sounds coming from the dunes at the top of the beach. It sounds like a child crying. When the concerned beach walkers investigate, they can find no one. There have also been reports of the sound of a woman wailing in pain and sorrow. These howls of misery cannot be ignored. Many people believe that these cries could be from the lost spirits of Jack, Quenza and her boy, Caesar. Was their suffering and anguish so intense that the energy remains to this day?

A local musician, James Shettleroe, plays folk and Celtic acoustic music at the Jupiter Lighthouse on a regular basis. The musicians play on a wooden deck that was built over an old well. One day, as he was playing his guitar, he felt something push on his instrument from the bottom. It was as if someone were standing behind him, reaching around to push the guitar away from his body. Most musicians don't care for strange people touching their instruments, so Jim got angry for a moment and whirled around to see who was doing it. No one was there. He was a little shaken, but he ignored it and continued playing. A few minutes later, as he was looking out at the small crowd of listeners in front of him, he heard a hollow "snap" sound, as if someone were flicking a large finger against the body of his guitar. He then heard another rapping sound, as if someone knocked it lightly with a fist. He was so shaken by this that he ended his session early that day.

What was the source of the contact Jim experienced that summer day? It is said that the Native Americans were fascinated by the stringed instruments that the Spaniards brought with them to the New World. Could this have been an encounter with a curious, mischievous Indian spirit? Could it have been the ghost of a child who liked the sounds that Jim was producing and wanted to investigate how it worked? Whatever the strange entity was, Jim feels that it was not of this world.

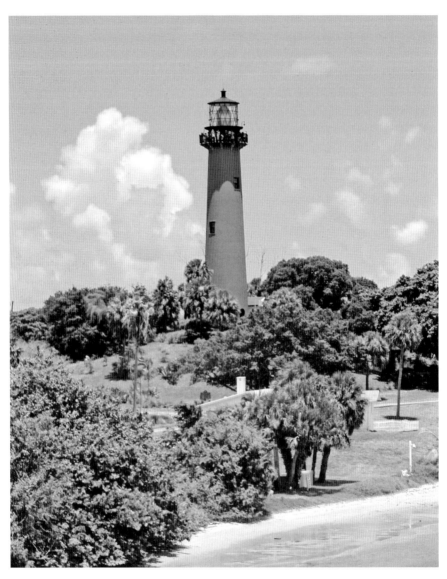

Jupiter Lighthouse today. *Authors' collection.*

# CONCLUSION

After the thousands of years of turmoil in this place, the spirits of those who struggled for survival here may still linger in the shadows, as if waiting for salvation from the mighty ocean itself. On dark, moonlight-filled evenings, as the briny wind blows gently through the softly rustling fronds of the towering palm trees, you can sit on the beach near the inlet and close your eyes. If you concentrate hard enough, you can let your mind wander to a different time, one before the condominiums, high rises and automobiles, when the place was wild and yet untamed. You might hear a faint sound. It could be the soulful, anguished song of the Jeaga holy men as they contemplate their existence in the only world that they knew. It could also be wails of lost mariners as they struggle to get to the beach after a shipwreck. Whatever it is, you will know then that you are in a very special place at the very south end of the haunted Treasure Coast.

We hope you have enjoyed these tales as much as we loved putting them down on paper for you. It is our belief that the Treasure Coast of Florida is one of the most beautiful and historically significant places in America. Please visit the sites you have read about here and decide for yourself what you will. One thing that does threaten the historical sites discussed here is the development that has taken place over the last thirty years. It is our belief that if we teach both the true history and rich folklore of the place, then citizens and visitors alike will make every effort to preserve its natural beauty for generations to come.

# Bibliography

## Books

Alexander, Michael and Theodore de Bry. *Discovering the New World*. New York: Harper and Row, 1976.

Bell, Emily Lagow. *My Pioneer Days in Florida, 1876–1898*. Miami, FL: McMurray Printing, 1928.

Du Bois, Bessie Wilson. *Jupiter Lighthouse*. N.p.: 1981.

Mann, Charles C. *1491: New Revelations of the Americas before Columbus*. New York: Knopf, 2005.

Mesmer, Patrick S. *The Pirate Santos: Curse of the Treasure Coast*. Stuart, FL: PM Consulting of Florida LLC, 2013.

Moore, Joyce Elson. *Haunt Hunter's Guide to Florida*. Sarasota, FL: Pineapple Press, 1998.

Snyder, James D. *Life & Death on the Loxahatchee: The Story of Trapper Nelson*. Jupiter, FL: Pharos, 2004.

Thurlow, Sandra Henderson, and Deanna Wintercorn. *Gilbert's Bar House of Refuge: Home of History*. Stuart, FL: Sewall's Point, 2008.

Wagner, Kip, and L.B. Taylor. *Pieces of Eight; Recovering the Riches of a Lost Spanish Treasure Fleet*. New York: Dutton, 1966.

Williams, Ada Coats. *Florida's Ashley Gang*. Port Salerno: Florida Classics Library, 1996.

# WEBSITES

jupiterlighthouse.org
loxahatcheeriver.net
verobeachdriftwood.com

# ABOUT THE AUTHORS

Patrick S. Mesmer is a project manager for a large corporation in South Florida. He also teaches at the local university, and his passions are history and music. This is his third published book. His other titles are *Haunted River Tales*, *Five Hundred Years on the Locha-Hatchee* and *The Pirate Santos: Curse of the Treasure Coast*. They are available on Amazon.com and at Barnes & Noble.

Patricia Ann Mesmer has a master's degree in mental health and operates a private counseling business. Her passions are family, helping distressed people and ghost hunting. (Not necessarily in that order!)

Patrick and Tricia have been happily married for over twenty-five years. Their company, Mesmerized Paranormal Investigations, has been helping people search for answers to these questions for many years now. They have also been operating a very successful and well-received ghost/historical tour business, Port Salerno Ghost Tours, in their hometown for the past four seasons. It seems that the popularity of the paranormal has caught on along the Treasure Coast in a big way!